IMAGES
of America

HAMBURG REVISITED

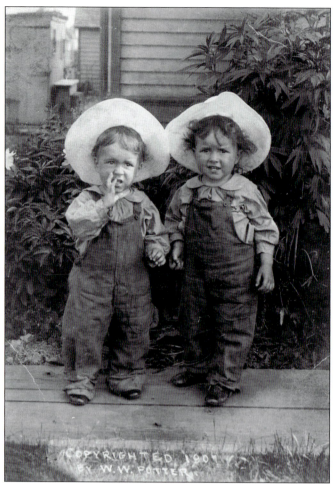

The Schwindler twins, Raymond and Richard, were born in 1905 and became famous when their Blasdell neighbor, photographer William W. Potter, took this picture of them and entitled it, "Say, Let's do him up," and the image appeared on a calendar. The Schwindler parents, Frank and Grace, had more children including Lawrence, Grace, Dorothy, Eileen, John, and Frank. The family lived on Gilbert Street, and at age 14, the twins worked as newsboys. Ray, known as "Windy," worked for Bethlehem Steel, and Dick had a long career with the Federal Reserve Bank. Hamburg, New York, is full of interesting people and interesting stories. (Courtesy of the Hamburg Town Historian.)

ON THE COVER. The group portrait shows employees of Biehler's Tea Room, the Palace Theater, and Biehler's dairy as everyone gathered for their annual picnic at the Biehler home in August 1946. From left to right are (first row) Laura Schall, Mary Sullivan Orr, Natalie Schutts Gaylord, Ann Zolk, Helen Parish, Gert Welsted, Kathleen Sullivan Cornell, Evelyn Biehler, Norman Biehler, Rosemary Asbury, Larry Bauer, Aylene Edie, Mrs. Gould, Cleo Mack, and unidentified; (second row) Harry Smith, John Stachera, Scott Strachen, Norm Biehler Jr., Rosemary Shu DuBois, unidentified, Florence Mumbach, Francis, Bertha Sullivan, Mrs. Wittmeyer, Mrs. Wittman, Miss Wittmeyer, Ann Borowski; (third row) Paul Sullivan, unidentified, Lloyd Schreiner, Ellen Sullivan Orr, Lloyd, Verna Wittmeyer Koester, Al Scheera, George Biehler, Marion Peters, Ralph Miller, Dolores Harvey, Billy Peters, Ralph Brock, Lee Peters, unidentified, and "Tarzan" Wood.

IMAGES
of America

HAMBURG REVISITED

John R. Edson

ARCADIA
PUBLISHING

Published by Arcadia Publishing
Charleston SC, Chicago IL, Portsmouth NH, San Francisco CA

Printed in the United States of America

Library of Congress Control Number: 2010920198

For all general information contact Arcadia Publishing at:
Telephone 843-853-2070
Fax 843-853-0044
E-mail sales@arcadiapublishing.com
For customer service and orders:
Toll-Free 1-888-313-2665

Visit us on the Internet at www.arcadiapublishing.com

*Dedicated to James D. Baker, Hamburg Town historian, who
generously shares his knowledge of Hamburg and Blasdell history
through his weekly newspaper column, "Out of the Past."*

CONTENTS

ACKNOWLEDGMENTS

This book was written with the generous help of the Hamburg Historical Society; the Hamburg Town Historian, James D. Baker; James Carlin; Donald Ahrens; Pete Brown; David Pound; Dr. Amos Minkel; Mr. and Mrs. Jimmy Barrett; George Emerling; Carl Kunz; Kathy Rice; and my friends and coworkers at the Hamburg Public Library. Unless otherwise noted, photographs are from the author's collection.

INTRODUCTION

Hamburg, New York, is a wonderful place to revisit, either in person or through a book. Since the town of Hamburg will celebrate its bicentennial in 2012, I thought this was a good time to write another book and offer 200 more photographs of Hamburg history to our community.

People ask me many questions about our town. Where exactly was Biehler's Tea Room, and what really happened to the legendary tunnels of the Nike Base? In Hamburg, when we give driving directions, we often mention what used to be at a location, such as, "Turn where the old Twin Fair store used to be." There is a big interest in history in this community.

When researching Hamburg history, I find many individuals who stand out from all the rest—people who seemed to be running most everything, people whom everyone seemed to love, and people that I wish I could know today. In this book, I wanted to include John W. Kleis, John W. Salisbury, Alma and Franc Titus, Arthur Howe, Elizabeth Seelbach, and Rev. Anthony Bornefeld as special favorites in Hamburg history. John W. Kleis helped his father construct the foundation for First Presbyterian Church in Blasdell with stones from their farm. Many people "lay the foundation" of a church by their deeds or financial support, but the Kleis men literally laid the foundation with stones and mortar. John W. Salisbury was a man of action, leading so many Hamburg organizations and opening his home to young men who boarded with his family when they first came to Hamburg. Some of his early boarders included Arthur Howe, Dr. Harrison V. Baker, and Donald Sharp. The Titus sisters, Alma and Frankie, reflect the "heart" of Hamburg, as they taught school in Blasdell for decades. Everyone seems to agree that they loved the schoolchildren, and in return, everyone loved them. I have used many of their personal photographs of life in Blasdell. I have read Elma's original contract with Blasdell Schools from 1935, which forbids female teachers to get married while employed. Arthur Howe, the namesake for Hamburg High School Howe Athletic Field, comes across as an inspiration even today. Art Howe came to Hamburg in 1920, married one of the other Hamburg High School teachers, settled on Highland Avenue, and actually cleared the land for the baseball diamond when it was still woods. Elizabeth Seelbach is another of my favorites; she served as the second librarian of the Hamburg Free Library for about 20 years, following in the footsteps of the illustrious Miss Amanda Michael. She served in the Red Cross during the First World War as the only woman from Hamburg who actually traveled overseas for the Red Cross. She also had a soprano singing voice. Rev. Anthony Bornefeld was the force behind the construction of the "new" Saints Peter and Paul Roman Catholic Church in 1910. Reverend Bornefeld had the taste for beauty and left his mark on the community. Many of today's elder Hamburg residents have told me stories about some of these historical people, including Doris Bruce who remembered a Sunday in 1920 when Reverend Bornefeld collapsed at mass shortly before he died.

Photographs in this book come from several sources: the collections of the Hamburg Historical Society, the Hamburg Town Historian, and many family and personal collections. Many people

have given me several of these old photographs, and in some cases these beautiful pictures, such as the boyhood photograph of Dr. Alvah Lord, have been rescued from the curb on trash day.

Beautiful buildings were plentiful in Hamburg 100 years ago. Two- and three-story brick structures lined the main streets of the Village of Hamburg. Residential streets boasted large, attractive residences with much decorative woodwork, due to the Hamburg Planing Mill that was located on West Union Street. Beginning in 1910, many of the old wooden buildings were replaced with larger structures made of brick and stone. This continued through the 1920s and many old wooden buildings, churches, theaters, and schools were demolished, making way for the new ones. Two Hamburg architects were responsible for most of these designs. Lawrence Bley and his associates designed Saints Peter and Paul Roman Catholic Church, the Hamburg Free Library on Center Street, The Palace Theater, St. James Evangelical Church, Armor School, the brick addition on the old Big Tree School on Bayview Road, and many homes throughout the village, including ones on Long Avenue. Frank A. Spangenberg designed the Masonic temple on Buffalo Street and the Hamburg High School, which is now the Pleasant Avenue side of the Union Pleasant Elementary School. Spangenberg also designed many homes throughout the village, including several on South Lake Street. His structures generally used classical elements, namely triangular pediments atop columns, but his signature seemed to be an arch worked in somewhere in the building design. I had hoped to find a decent photograph of Spangenberg for this book, but have been unsuccessful. Throughout the Village of Hamburg, you can spot homes that he designed; generally they break away from the foursquare style of the 1910 era, and they are loaded with influences from other times and places. The Spangenberg signature is an arch somewhere in the building, perhaps a Palladian window, a half-moon window, or a curve to the roofline. Spangenberg died suddenly in 1932, leaving a growing family and a number of unfinished projects.

Hamburg has a history of gigantic parades and fairs that people anticipate and that attract people from far and near. The Hamburg Volunteer Fire Department organized many parades that attracted thousands of people each summer. The largest celebration on record was the Hamburg Centennial, or "Old Home Week," a five-day celebration of the founding of the town in 1812. Many photographs of this event and other firemen's celebrations show an endless parade of firemen, and the buildings on Main Street were festooned with patriotic bunting and decorations to welcome firemen from other communities. The Erie County Fair was another annual magnet that drew people to Hamburg during the summer. I was fortunate to borrow an old fair Premium Book from 1909 and show some of the activities from the fair that year including a baseball game, agricultural exhibits and competitions, and horseracing at the track. This fair began here in 1868, and one wonders how many thousands of people have visited, or revisited, Hamburg since that time.

I have been given other recollections and anecdotes from many Hamburg seniors including Dr. Amos Minkel, Donald "Duke" Spittler, Jim Baker, Jim Carlin, and Fred Sawers.

In many ways, I write Hamburg history books to pass along the stories that people have told me about what Hamburg was like back in the olden days. From everything I have read and from everything I have heard, it certainly was a wonderful community, one we want to revisit at any opportunity. When reading this book, I hope people will discover just what it was that made Hamburg such an interesting and warm place and try to nurture those qualities in Hamburg today, making it a place people will want to keep revisiting in the future.

—Jack Edson,
February 22, 2010

One

The Personalities that Made Hamburg Great

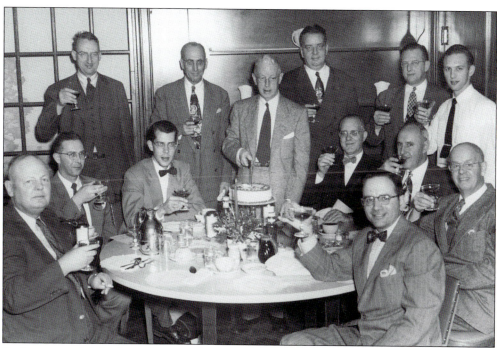

Businessmen, civic leaders, clergy, teachers, parents, and just ordinary folks have made Hamburg the great place it is. This photograph shows Hamburg businessmen, including Chuck Siebert; Don Korst; Maxwell Eaton; Charles W. "Bud" Kronenberg; Mr. Richards; Bud Helwig; realtor J. Leo Goodyear, who served as village mayor from 1951 to 1955 and town supervisor from 1956 to 1957; Norman Biehler Sr.; Norman Biehler Jr.; and photographer Louis Sheff. (Courtesy of the Hamburg Historical Society.)

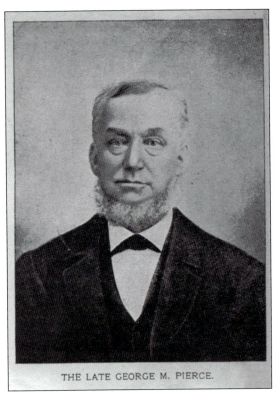

THE LATE GEORGE M. PIERCE.

George M. Pierce was born in 1823 and served as the first president of the village. The Pierce family began as farmers, but George and his brother Oliver started many enterprises including a sawmill that ran night and day to supply the growing city of Buffalo with lumber. He was the president of the Erie County Agricultural Society and the Bank of Hamburgh, and he organized the Hamburgh Canning Factory and the Planing Mill. (Courtesy Hamburg Historical Society.)

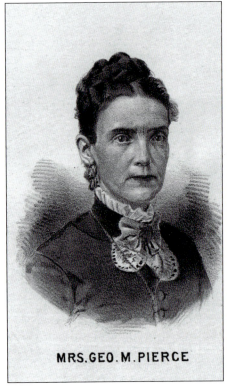

MRS. GEO. M. PIERCE

Harriet Dwight was born June 21, 1840, in Niagara County, New York. After her father died, her mother married Aaron Gould in 1855, and they moved to Big Tree. Harriet was active in the Lake Street Presbyterian Church. In spite of her family's wealth, she was known for a simple life, devoted to her family, friends, and neighbors.

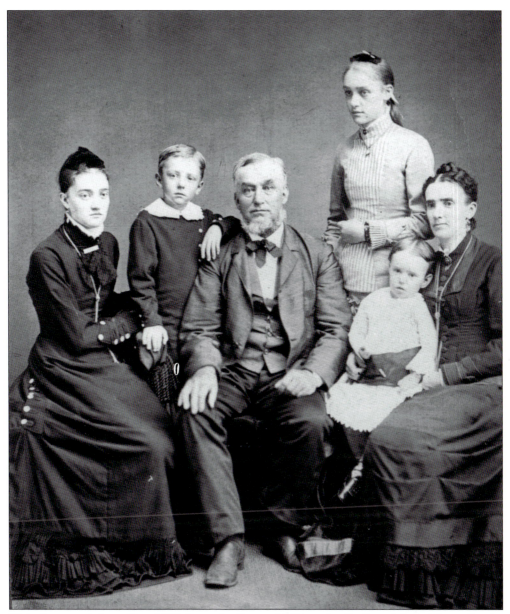

This photograph from about 1880 shows the George M. Pierce family. From left to right are Louisa Sarah, Daniel C., George M., Carrie, Bessie, and Harriet Dwight Pierce. The Pierces had four children who died young, in addition to their four children who survived to adulthood: Daniel C. Pierce, Louise S. (Mrs. William Kronenberg), Carrie M. (Mrs. Frank Martin), and Bessie E. (Mrs. John P. Leavitt). Louise (1859–1946) was an elegant lady who travelled through Hamburg in a chauffeured automobile. Daniel C. Pierce (1874–1923) became a leading businessman after the death of his father. He and his wife, Katherine, had two children, Helen and George M. Pierce. He is not to be confused with his cousin Daniel B. Pierce of Water Valley. Carrie became the wife of Frank S. Martin, but she died October 28, 1907, leaving two children, Cedric and Paul Martin, in Puyallup, Washington. Bessie married John P. Leavitt, and they moved to the state of Washington. (Courtesy Hamburg Historical Society.)

Milford Fish served as the second president of the Village of Hamburg from 1876 to 1879. He was born in Hamburg January 31, 1829, and died October 7, 1895. He was a dry goods merchant here and is remembered for his ingenious telescope and observatory that is shown on page 44. (Courtesy Kathy Rice.)

Milford Fish and his wife, Hannah, had five sons. From left to right are Clinton E., Milton M., Burton F., Newton C., and Howard J. Fish. Burton M. Fish established the B. M. Fish Dry Goods Store at Main and Buffalo Streets, which burned in 1917. He and his wife, Carrie, lived at 40 Union Street. Besides these sons, Milford and Hannah Fish had several daughters: Emma, Florence, and Carrie. (Courtesy Kathy Rice.)

Hannah Colvin was the wife of Milford Fish and was born December 8, 1830, in Hamburg village. Her parents were Poultice and Eliza Colvin, and her father was an early village dry goods merchant. She and Milford Fish lived in an attractive home, with an observatory, on Buffalo Street at Union Street. This house has been moved twice and is located on East Prospect Street now. (Courtesy Kathy Rice.)

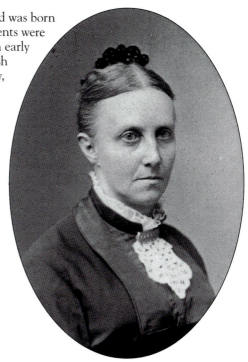

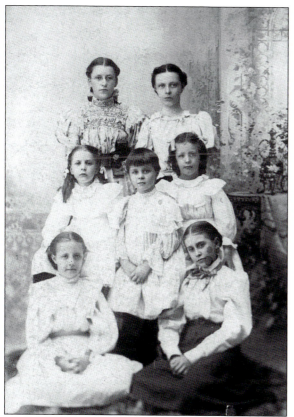

Milford and Hannah Fish had many grandchildren, including these granddaughters shown in this 1895-era portrait by Hamburg village photographer and druggist E. G. Nott. From left to right are (first row) Ethel Fish Montgomery and Leska Fish; (second row) Laura Fish Mordoff, Grace Leaing, and Minnie Fish Piper; (third row) Catherine Fish Newell and Mildred Fish. (Courtesy Kathy Rice.)

13

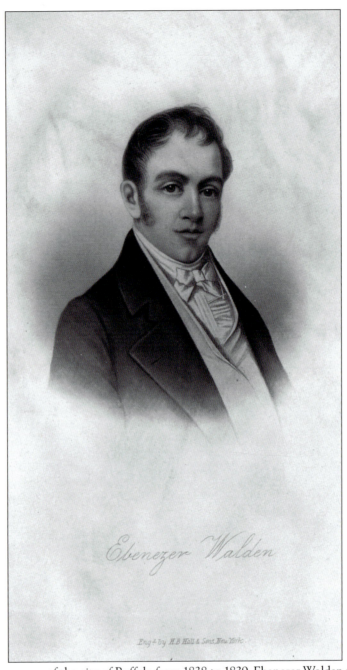

Eng'd by H.B. Hall & Sons, New York.

After serving as mayor of the city of Buffalo from 1838 to 1839, Ebenezer Walden moved to Lake View to live near his son James who was the first postmaster of Lake View. Ebenezer Walden married Suzanna Marvin in 1812 and began investing in real estate, thereby becoming one of the wealthiest men in Buffalo. Judge Ebenezer Walden named the small community "Lake View" and built the Lake View Hotel near the train station. The Walden name is used for Walden Avenue in Buffalo, reflecting the vast early land holdings of Ebenezer Walden. Ebenezer Walden died in Lake View on November 10, 1857, and was buried in the opulent Walden-Myer Mausoleum in Forest Lawn Cemetery. (Courtesy Hamburg Historical Society.)

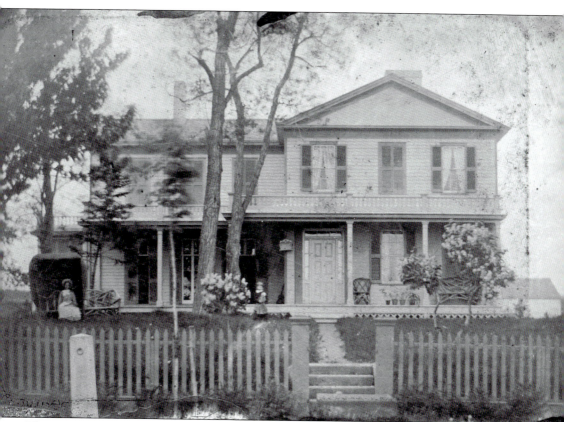

This tintype from about 1880 shows Ebenezer Walden's Lake View home that stood on the east side of Old Lake Shore Road north of Lake View Road. Walden's daughter Catherine married a famous surgeon and military man, Gen. Albert J. Myer, and the Myers lived in this home after the death of Judge Walden. Gen. Albert J. Myer developed a system of army signal communication that used flags and torches. He served in the Civil War as signal officer to General McClellan and participated in the battles of Bull Run and Antietam. Albert Myer rose to the rank of brigadier general on June 16, 1880, but died two months later at the Palace Hotel, run by Dr. Ray Vaughn Pierce. (Courtesy Hamburg Historical Society.)

The congregation of the United Evangelical Church of White's Corners, later know as St. James Evangelical Church, was organized in 1853. In 1920, Rev. Albert E. Viehe came from Cincinnati and a building committee was formed to construct a new, large brick church. Reverend Viehe was born October 1874, and he and his wife, Martha, had two sons, Theodore and Carl. The congregation of St. James prospered under Pastor Viehe who worked diligently until his death on September 27, 1938. (Courtesy St. James United Church of Christ.)

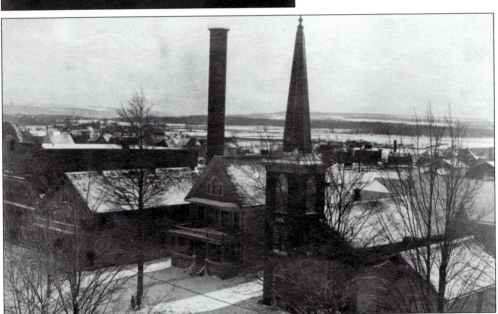

Several Main Street landmarks are shown in this 1905 photograph: the Dietrich Building, St. James parish hall, the tall village water tower, St. James parsonage, and the original wooden church. The original mid-19th-century wooden church was replaced during the 1920 decade with a new, larger brick structure. The new St. James Church was designed by Hamburg architect Lawrence Bley, and the cornerstone was laid on July 20, 1924.

Rev. Anthony H. Bornfeld was born in Germany December 3, 1864, and ordained a priest in Belgium in 1890. He served as pastor of Saints Peter and Paul Roman Catholic Church from 1900 to 1920. The Catholic population of Hamburg grew rapidly and Reverend Bornfeld decided to have a new brick church built to accommodate the growing congregation. Reverend Bornfeld collapsed in the church sanctuary and died some days later on April 7, 1920.

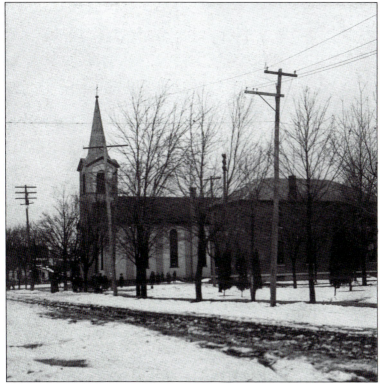

This stereocard image from about 1905 shows the second church structure of Saints Peter and Paul Roman Catholic Church that was constructed in 1863 and replaced by the Romanesque and Gothic-style church built in 1911. This earlier brick structure had a single tower and steeple. The second parochial school is shown to the right of the church, and it was constructed in 1874 under the direction of Rev. Vincent Scheffels and run by the Sisters of St. Francis.

17

John W. Salisbury, 1856–1935, was a dealer in farm implements, Hamburg Village postmaster, leader of the Peoples Bank and the Erie County Agricultural Society, president of the Hamburg School Board, and fire chief from 1902 to 1903 and 1910 to 1912. He had the Salisbury Building erected at 22 Main Street with its distinctive pressed metal facade. Salisbury's family was very active in Hamburg events, including his sister Lorinda Colvin who recorded early Hamburg history and wrote poems for civic occasions. His first wife, Lillie, died in 1892, and his second wife, Edith Dietrich, raised a second family in their large home at 128 Pleasant Avenue. The Salisburys took in boarders including Arthur L. Howe, Dr. Harrison V. Baker, and Donald Sharp. John W. Salisbury is remembered as a dynamic individual who spoke a colorful language, peppered with blasphemies. (Courtesy Hamburg Volunteer Fire Department.)

Horace Paxson was born in Eden on January 28, 1838, and enlisted in the Union army in 1862, serving in Company K, 116th New York State Volunteer Infantry. He lived at 180 Main Street in Hamburg Village, married Mary A. Kester, and they had one daughter, Gracia Paxson. Horace Paxson studied dentistry with Dr. Charles W. Morse and practiced dentistry in Hamburg from 1886 to 1923. He died March 9, 1925. (Courtesy Hamburg Historical Society.)

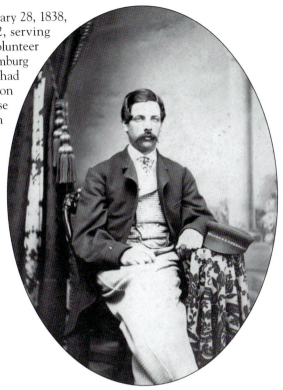

Dr. Gracia A. Paxson was well known for her long career as Hamburg's woman dentist. She was one of three women in a class of 70 students at the University of Buffalo. After graduation, Gracia worked with her father at 180 Main Street, but he would not let her extract teeth, lest she damage her hands. This woman worked as a village dentist for over 50 years then married Edward J. Hackemer in 2002 at age 75. (Courtesy Hamburg Historical Society.)

Eugene Alonzo Van Pelt was born in 1845 and served as Hamburg's truant officer from age 70 to 90. He spent his time trying to convince students and their parents of the reasons why they should attend school and get an education. Kids felt "Gramps" Van Pelt understood the younger generation, and on the occasion of his 90th birthday, students contributed over 3,000 pennies to buy him a present: a silver loving cup that they paid for themselves. Van Pelt was a Mason for 72 years before he died in 1940.

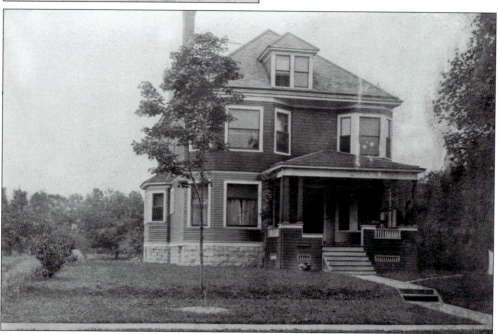

This large and attractive home at 78 Pleasant Avenue has changed little since it was built about 1905. At that time, it was home to the Sara Maybach family, but it is best remembered as the home of Eugene Alonzo Van Pelt until his death in 1940.

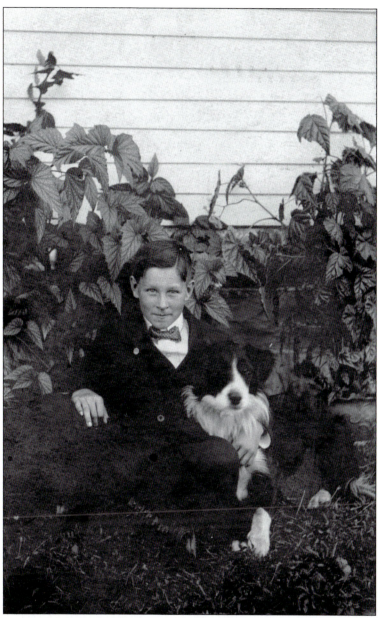

Dr. Alvah Leon Lord was born in Leon, New York, in 1895 and came to Hamburg with his family in 1899. From 1907 to 1917, he was influenced by his coach George Platt, who taught "Ad" Lord football, basketball, and hockey, playing hockey on the frozen creek behind the Hotel Hamburg. During medical school, he was sent to a Lackawanna hospital during the 1918 influenza epidemic, even though he was not yet a doctor. He married Frances McMichael, and they moved to 147 Main Street in Hamburg Village in 1922. During his 42-year practice, Dr. Lord wore snowshoes for winter house calls and delivered over 3,400 babies. At one home delivery, Dr. Lord looked up to see the mother's eight children watching, even the youngest that had bumped his crib across the room to watch. Five hundred people celebrated Dr. Lord's long career in Hamburg with a dinner in his honor on September 21, 1964. Dr. Lord's house was moved to the grounds of the Hamburg Historical Society in 1979. This photograph shows young Alvah with his dog "Tip" in 1908.

William Kronenberg married Louise Pierce, daughter of George M. Pierce, and they had three children. After Louise received a large inheritance, William still served as president of the Hamburgh Canning Company and as one of the directors of the Bank of Hamburgh. Kronenberg was a member of many fraternal organizations, and this photograph shows him (far right) at a fire department event in 1913. William Kronenberg died October 30, 1930. (Courtesy George Emerling.)

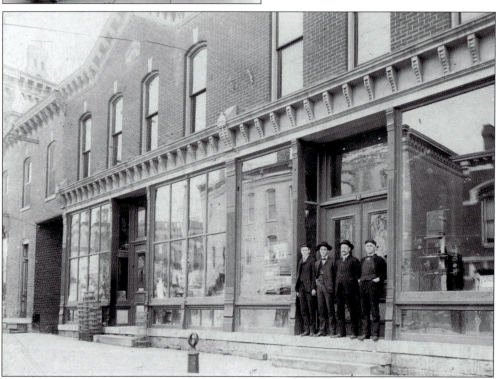

This 1904 photograph of the Fish and Kronenberg Store on Main Street shows the details of the 1884 building that housed the business of Newton Fish and Joseph and William Kronenberg. The men standing in the doorway are, from left to right, Marvin Schwert, Charles B. Kronenberg, Newton Fish, and long-term employee Simon P. Rose. (Courtesy David Pound.)

Charles B. Kronenberg cut the large cake to celebrate the 100th anniversary of Kronenberg's Store that was held in the Hotel Hamburg on September 29, 1948. Charles W. Kronenberg had joined the company in 1904, succeeding his father and grandfather, William and Charles Kronenberg, who established the family business in the village of Hamburg. (Courtesy Mr. and Mrs. Jimmy Barrett.)

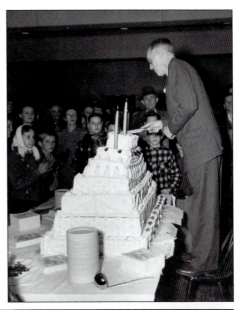

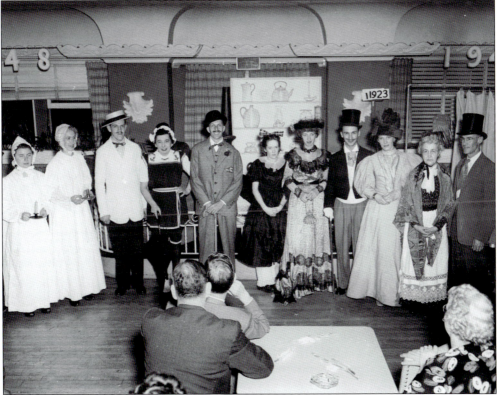

Kronenberg Store employees presented an elaborate theatrical program to celebrate the 100th anniversary of their store in 1948. Many employees had joined the "25-Year Club" after working for Kronenbergs for over a quarter century. Kronenberg employees dressed in early costumes and showed how things had changed at the store over the past 100 years. (Courtesy Mr. and Mrs. Jimmy Barrett.)

William L. Froehley, born June 1882, was the third generation of the Froehley family furniture and undertaking business that was operated on Lake Street, in the Grange Building on Main Street, and on Lake Avenue in the village of Blasdell. Constantine Froehley established the business in 1877, and it was later run by his son William C. Froehley until his death August 1922. (Courtesy Hamburg Historical Society.)

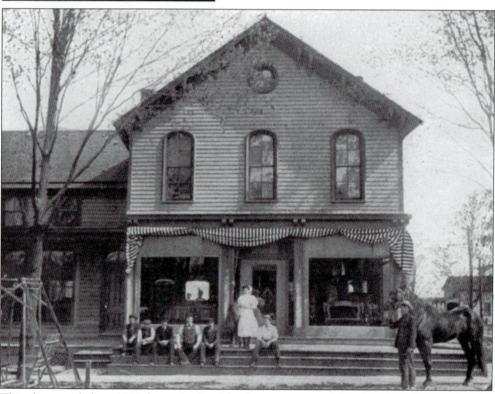

This photograph from 1910 shows the Froehley furniture store and undertaking business on the corner of Lake and West Union Streets. Many furniture stores also sold coffins, and a business that combined furniture and undertaking was not uncommon. Hamburg's early undertakers included Froehley, Dietrich, and Fogelsanger. (Courtesy Hamburg Historical Society.)

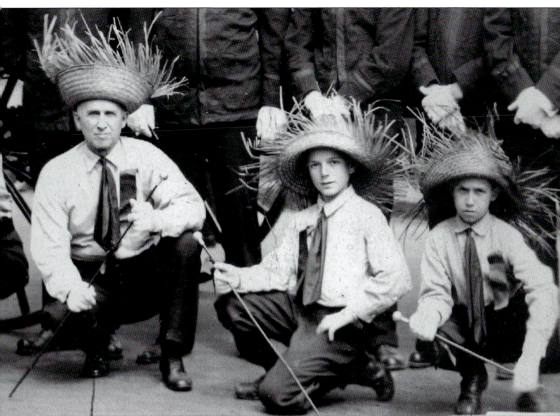

This 1913 photograph shows two of Hamburg's leading musicians, Simon P. Rose at left and his son Werner Rose at right. Simon Rose was born in 1847 and travelled with the Barnum and Bailey Circus Band and led the Hamburg Cornet Band. After the death of his first wife, he married a young musician, Mary Werner, who gave birth to their son Werner, a versatile musician who performed professionally while he was still in high school at the Hamburg Academy. Dr. Werner Rose directed the Hamburg Village band for 15 years and was active in the Harmonic Club, in addition to his professional career as a heart specialist. The boy in the center of the photograph is Arthur Espenscheid, son of wagon maker John Espenscheid and his wife, Susan. (Courtesy Hamburg Volunteer Fire Department.)

Ellen Beach Yaw was born in nearby Boston, New York, on September 18, 1868, and became a famous singer knows as "The Lark" for her soprano voice. She could trill on high notes like a lark, and she called this her "Eiffel Tower note." In 1904, her cousin Clara Yaw arranged for Ellen to perform at Kopp's Opera House at a benefit for the Hamburg Free Library. The proceeds were used to purchase the "Lark Ellen" bookcase for the library.

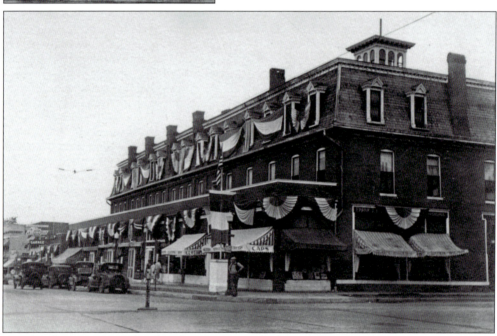

In its heyday, Kopp's Hotel and Opera House was the largest place for Hamburg people to gather and socialize. Ellen Beach Yaw and many other performers appeared on the stage of Kopp's Opera House. George Kopp was born in Ranschback, Bavaria. He married Juliana Berlenbach and built a tavern at White's Corners in 1857. (Courtesy Town of Hamburg Historian.)

Dorothy Thompson was born July 1893. After leaving Hamburg, Dorothy married three times, including a marriage to the writer Sinclair Lewis. She travelled the world as a noted columnist and news analyst. She described her early days in Hamburg in the picture book, *Once on Christmas*, illustrated by Lois Lenski. Dorothy Thompson revisited Hamburg on October 24, 1950, and gave a lecture called "These Crucial Days" to a packed house at the grade school auditorium. (Courtesy Hamburg Historical Society.)

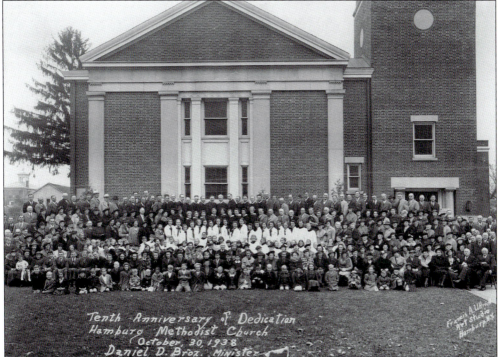

The Hamburg Methodist Church had grown after Dorothy Thompson's father, Rev. Peter Thompson, left as pastor. This attractive brick and stone church replaced the wooden church where Reverend Thompson had served. This church was designed by North and Shelgren Architects and dedicated October 28, 1928. The congregation gathered for this photograph to celebrate the 10th anniversary of their new church building on October 30, 1938. (Courtesy Hamburg Town Historian.)

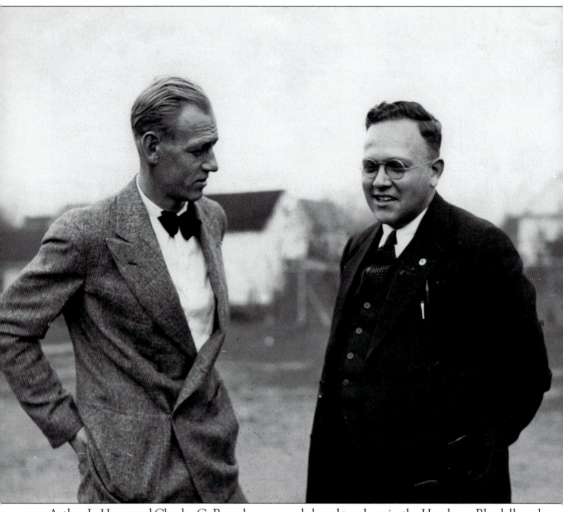

Arthur L. Howe and Charles G. Buesch were much-loved teachers in the Hamburg, Blasdell, and Frontier Central Schools. Art Howe was born in Wisconsin and came to Hamburg in 1920 to teach physical education. He married Hamburg High mathematics teacher Martha Higgs, and they lived on Highland Avenue with their two sons. Howe coached football, basketball, and baseball, and he became a great friend to students and to the community at large. The Hamburg High School athletic field was dedicated in his name on October 7, 1950, during a football game. At halftime, the marching band performed a drill that spelled out "ART" and each bandsman left a flag on the field, leaving Howe's name written on the field with flags. He passed away November 8, 1961. Charles G. Buesch gave 34 years to teaching, including 26 years in the Blasdell and Frontier Districts. He coached many championship sports teams at Blasdell High School. He was instrumental in centralizing eight school districts, establishing the Frontier Central District in 1951. He passed away May 17, 1961. (Courtesy Hamburg Historical Society.)

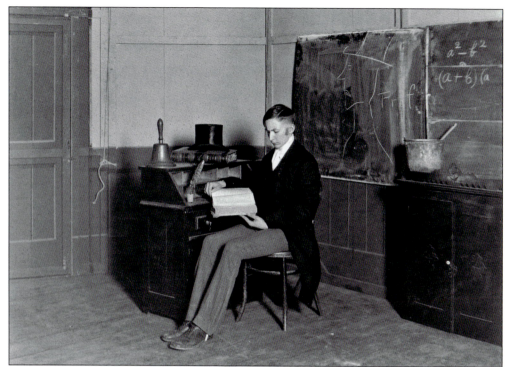

In 1928, John W. Kleis portrayed an early schoolmaster, and in real life, he served the community with a lengthy series of terms on the school boards of the Big Tree School and the Frontier Central District once it was established in 1951. His father, John H. Kleis, settled on the Mile Strip about 1870, and he and his sons worked to build the First Presbyterian Church structure on Lake Avenue in Blasdell. (Courtesy Hamburg Historical Society.)

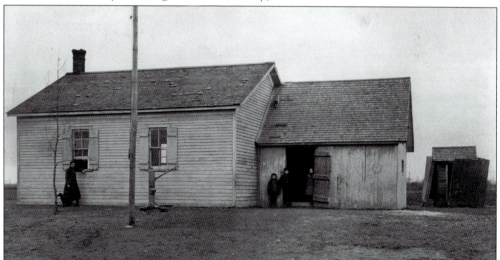

This humble building was erected in 1872 and served as District School No. 7 for the Big Tree Community. It was moved from its original location on Buffalo Road—today's South Park Avenue—at Bayview Road, to the intersection of South Park Avenue and Big Tree Road in 1907. In White's Corners, William W. Hammond taught school when he was 18 years old. (Courtesy Hamburg Historical Society.)

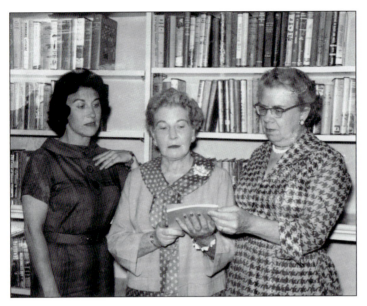

Anne Frank Hammersley started her librarian career in 1912 at age 20. In 1943, she accepted the job as head librarian of the Hamburg Free Library on a temporary basis, but went on to lead the library for 17 years until she retired in 1961. In this 1960 photograph, Mrs. William Luby and Mrs. Ross Duffett present a book to Mrs. William W. Hammersley. Hammersley died November 11, 1983, at age 91. (Courtesy Hamburg Public Library.)

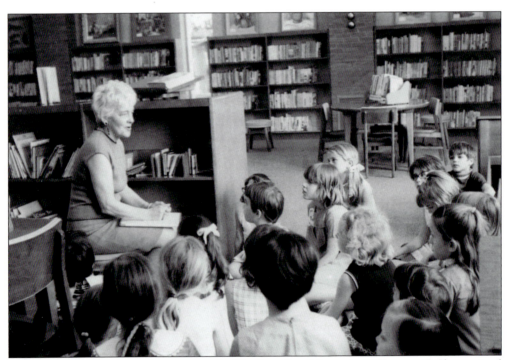

Jean C. Shaughnessy began her career at the Hamburg Free Library in 1956 at age 47. She received her library science degree in 1962 and replaced Mrs. Anne Hammersley as director. In 1966, under Jean's directorship, two new federally funded libraries were opened: the Hamburg Public Library on Buffalo Street and the Lake Shore Public Library on Lake Shore Road. (Courtesy Hamburg Public Library.)

The Blasdell schools were noted for their devoted teachers who had lengthy careers and dedicated their lives to their students. The Titus Sisters, Elma and Franc, gave a large collection of photographs and papers to the Hamburg Historical Society, and these artifacts tell the story of life at the Blasdell schools from 1925 to the 1960s. This photograph shows Elma Titus, left, with Blasdell's kindergarten teacher Hildegarde Cordt in 1926. (Courtesy Hamburg Historical Society, gift of Franc Titus.)

The Blasdell High School was expanded in 1925–1926, and grades 3, 6, and 7 met in the basement during construction. That year, the kindergarten classes were held down the street at the Blasdell Chapel. (Courtesy Hamburg Historical Society, gift of Franc Titus.)

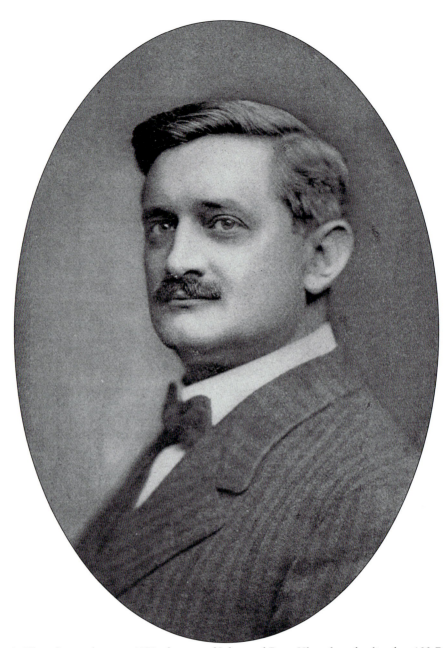

John A. Kloepfer was born in 1873, the son of John and Rosa Kloepfer, who lived at 103 Buffalo Street and ran Kloepfer's Hotel on Main Street in the village of Hamburg. As a young man, he worked as a cashier at the Bank of Hamburgh, and then went on to become the president of Liberty Bank in Buffalo. He was married to Alida Kloepfer and was a natural leader, directing the Erie County Agricultural Society and the Hamburg Free Library. He died suddenly in 1927, leaving a large estate that gave sizeable amounts of money to many organizations in Hamburg, including the Hamburg Free Library. At the dedication of the John Kloepfer Library Room, Miss Florence Eckhart said of him, "When he grew up to become a rich and successful man, he never forgot the village. He was handsome and kind; we were always proud when we saw him walking on our streets."

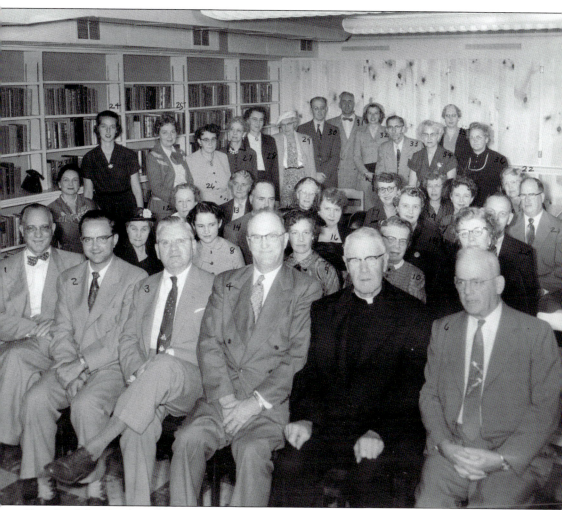

Friends of the Hamburg Free Library gathered on September 15, 1954, to dedicate the John A. Kloepfer Room. Guests included 1) J. Leo Goodyear, Mayor of Hamburg; 2) Kloepfer relative; 3) Albert C. Knaack, library trustee; 4) John McQuade, library trustee; 5) Rev. Anthony J. Veit; 6) Edwin Bundy, library trustee; 7) Elizabeth Rae Seelbach, librarian, 1922–1943; 8) Joan Davis, junior librarian; 9) Neva Sherwood, library trustee; 10) Anne Frank Hammersley, librarian, 1943–1961; 11) Evelyn Banwell, library treasurer; 12) Ruth Talamo, library board secretary, 1925–1950; 13–16) Kloepfer family; 17) Florence Eckhardt; 18) Kloepfer family; 19) Ruth G. Stuhr, library staff; 20–24) Kloepfer family; 25) Evangeline McQuade; 26) Marguerite Klispie; 27) Martha Viehe; 28) Cecelia Pauly; 29) Mrs. Clara Wheelock Titus, one of the library founders; 30) Edward A. Pauly, architect; 31) William Haberer; 32) Mrs. Haberer; 33) Raymond J. Emerling Sr., supervisor of the town of Hamburg; 34) Mrs. Emerling; 35) Viola Miller, library clerk; 36) Mrs. Edward Bundy. (Courtesy Hamburg Public Library.)

Capt. Braley Kelley Buxton built this handsome brick home on Pleasant Avenue and what is now Southwestern Boulevard about 1850. Buxton married his wife, Harriet Phillips, in 1837, and they had 15 children. This land was rich in clay deposits, and the family made their own bricks before and after school to construct their fine house. (Courtesy Hamburg Historical Society, L.A. Hazard Lake View Collection.)

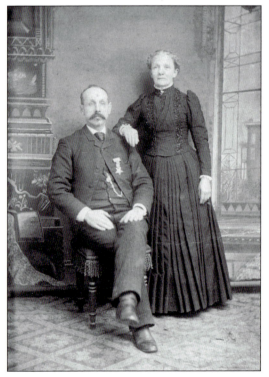

Spencer Buxton (1839–1901) was the eldest son of Captain Braley and Harriet Buxton. He married Seraphine Wood (1841–1927), and they moved to Manawa, Wisconsin, in the 1880s. After the death of Braley Buxton, Spencer moved his family to the home on Pleasant Avenue. Spencer and Seraphine were married December 26, 1864, and their children were Cora Lee, Leroy, Ella, Harriette, Aday, and Lemuel Buxton. Adah married Will Meyn, who ran the Lake View store and post office, and she later married Frank Benjamin. (Courtesy Hamburg Historical Society, L.A. Hazard Lake View Collection.)

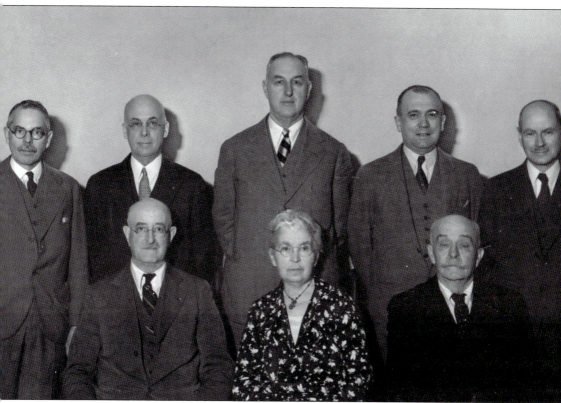

Joseph E. Leach arranged for a reunion of early Hamburg School Board members, held on October 18, 1932, to coincide with his retirement as school tax collector, a position he held since 1904. This group portrait shows past presidents, from left to right, (first row) Newton C. Fish; Carrie E. Fish, the "First Lady Member"; and John W. Salisbury; (second row) A. C. Parsons, L. M. Potter, Carlton E. Eno, Henry R. Stratemeier, and tax collector Joseph E. Leach. At the festivities, John W. Salisbury recalled the name of the village changing from Smith's Mills to Shepherd's Corners to White's Corners. Perry M. Thorn remembered the days when "lady teachers" were a minority, because the "stern masculine hand of a professor was needed to handle the unruly big boys of the student body." Joseph Leach mentioned his father, Dr. Leman R. Leach, was president of the board of education in 1894 when the Hamburg Academy became a public school. His brother Rev. Frank P. Leach was the first student to receive a diploma from the school. (Courtesy Hamburg Historical Society.)

George Burwell Abbott was the son of Hamburg physician Dr. George Abbott and Julia C. Abbott. Burwell married May McLaurie and they moved to Salamanca, New York, where he ran a clothing business, became mayor, and organized a volunteer fire department. In the 1890s, the Abbotts moved to Cheyenne, Wyoming, where he settled hand claims in the Wild West. About 1902, the Abbotts moved back to Hamburg and Burwell got involved in politics again, being elected tax collector then Erie County Supervisor. Before Abbott served as supervisor, Hamburg had only 22 miles of state and county roads, but during his terms, Southwestern Boulevard, McKinley Parkway, Bay View, and Sowles Road were paved. Burwell started a school-bussing program for rural children, he was instrumental in buying property on Lake Erie for Hamburg Beach, and served as president of the Erie County Agricultural Society. He died February 4, 1942, at age 84. (Courtesy Barbara Fox.)

John Van Epps ran a candy shop and dealt in Kodak film products. He is best remembered for producing a vast assortment of picture postcards of Hamburg using his own photographs. George Burwell Abbott served several terms as Hamburg Town supervisor and was Erie County supervisor for 17 years, bringing many highways and bridges through Hamburg. He was a leader of the volunteer fire departments in Hamburg and Salamanca, organizing and promoting parades and conventions. Alexander C. Stolting was a lawyer and proprietor of the *Erie County Independent* newspaper beginning in 1867 with Charles W. Sickmon as editor. Stolting was a Civil War veteran and had lost one arm, but that did not prevent him from running his newspaper. He organized able-bodied men of Hamburg to form the volunteer fire department, and he was the first fire warden and slept beside the fire equipment. From left to right are John Van Epps, George B. Abbott, and Alexander Stolting. (Courtesy Hamburg Volunteer Fire Department.)

This attractive postcard was photographed by John Van Epps and shows a scene at Water Valley of a steam engine crossing the railroad trestle above Eighteen Mile Creek at Water Valley. Van Epps had a great talent for photography, and his numerous postcards spread images of Hamburg around the country.

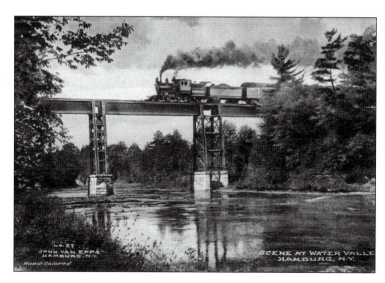

Hamburg architect Lawrence H. Bley was born on December 15, 1884. The firm of Bley and Lyman designed many churches, schools, and businesses in Buffalo and its suburbs. In Hamburg, Bley designed St. James Evangelical Lutheran Church; Saints Peter and Paul Roman Catholic Church, School, and Rectory; the Hamburg Free Library; the Odd Fellows Temple; the Palace Theater; Peoples Bank; the Peoples Bank, the Community Wayside Church on Lake Shore Road; the Armor School; and many village homes. He was active in many organizations, serving as president of the Co-operative Savings and Loan Association, president of the Hamburg Free Library Board, and a director of the Hamburgh Planing Mill. He married Matilda A. Schummer in 1909. Bley lived at 294 Long Avenue and died May 6, 1939. (Courtesy Hamburg Historical Society.)

Hamburg businessman George J. Biehler was born in East Eden, New York, in 1883. After he married Anna Brenner and moved to Hamburg in 1914, he built the Palace Theater that opened in 1926. In February of that year, George Biehler bought the store of Robert W. Hengerer. Norman Biehleran ran Biehler's Tea Room, a favorite place for people to gather for a meal or a soda. In 1946, George and his son Norman purchased the Hotel Hamburg. The Biehlers ran a dairy for 20 years on their farm in the Boston Valley. George J. Biehler died in February 1949 at the age of 66. (Courtesy Hamburg Historical Society.)

The Biehlers' attractive home at 94 Pleasant Avenue at Hawkins Street features a wraparound veranda with craftsman-style details. The spacious lot had ample room for a barn behind the house. George J. Biehler lived here in 1920 with his wife, Anna, and their children, Raymond, Norman, and Verona.

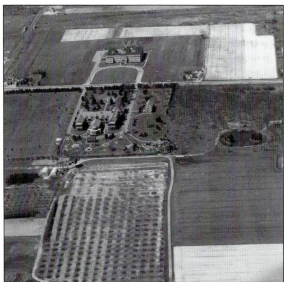

The Franciscan Sisters of St. Joseph moved from Corpus Christi Church in Buffalo to South Park Avenue in Hamburg in 1925 under the leadership of Mother Clara. This aerial photograph from 1950 shows their convent St. Anthony's Home for the Aged, their farmland, water tower, and the little pond that is now at the entrance to Hilbert College.

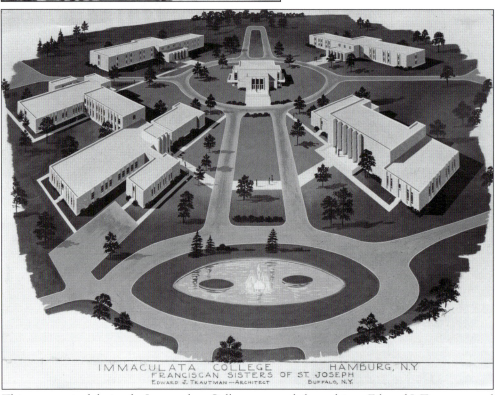

IMMACULATA COLLEGE HAMBURG, N.Y.
FRANCISCAN SISTERS OF ST. JOSEPH
Edward J. Trautman—Architect Buffalo, N.Y.

This symmetrical design for Immaculata College was made by architect Edward J. Trautman and incorporated the existing little pond and islands into the college setting. Ground was broken June 11, 1967, for the $3 million campus of this junior college on South Park Avenue by college president Sr. Mary Edwina Bogel, FSSJ and Mother Mary Arcadia, FSSJ. One day prior, 35 graduates had completed their studies in the temporary quarters of the order's motherhouse. This event was a step changing the work of the FSSJ order from caring for the aged to education-based. (Courtesy Hamburg Chamber of Commerce.)

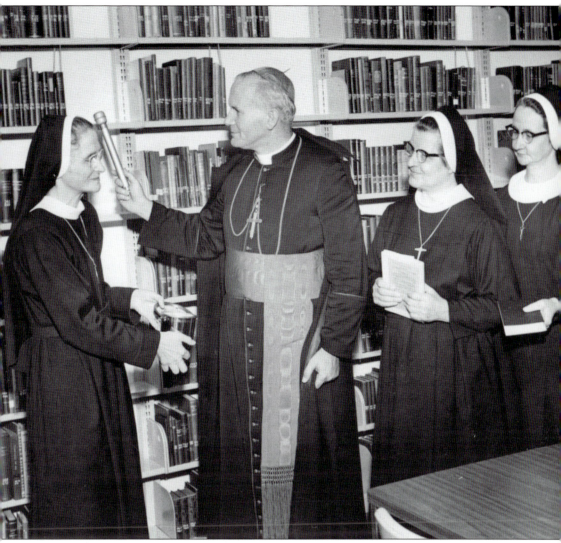

Card. Karol Wojtyla visited the Franciscan Sisters of St. Joseph (FSSJ) on September 17, 1969, and blessed the Polish collection of books and artifacts. On October 16, 1978, Cardinal Wojtyla was elected pope, taking the name John Paul II and beginning his lengthy and historic papacy that ended with his death on April 2, 2005. From left to right are Hilbert College president Sr. Mary Edwina Bogel; Cardinal Wojtyla; FSSJ Superior Sister Mary Arcadia; and Sister Tiburtia, librarian. On May 13, 1981, a man shot at Pope John Paul II in Rome and Western New York resident Ann C. Odre was also wounded in the incident. (Courtesy Hamburg Town Historian.)

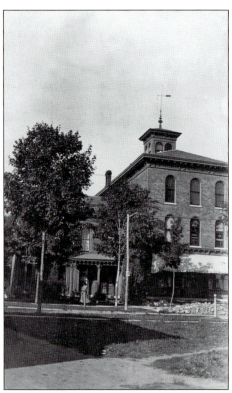

John G. Brendel came from Bavaria to Hamburg in 1850 and had this three-story brick building erected in 1876. It was used for a store and family home, and the Hamburg Grange had meetings on the third floor. John and Anna Brendel's family included their children Emma, George, Katie, Charles, and Marcus. Frank Brendel became a physician, Marcus became an attorney, and George took over the family business. In 1908, this section of Main Street had not yet been paved in front of this beautiful Italianate building.

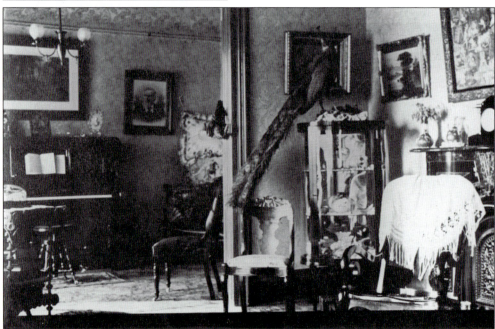

This is the interior of the Brendel home in 1908, when George Brendel ran the family store on Main Street in addition to developing a subdivision of homes and being one of the founders of the Hamburg Savings and Loan Association. The Brendel home is full of Victorian furnishings and shows us how Hamburg's wealthier families lived.

Two

EARLY DAYS OF HAMBURG

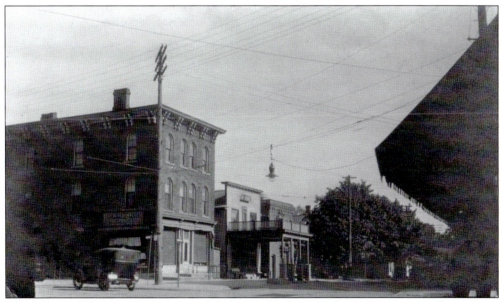

The village of Hamburg had plenty of charm at the dawn of the 20th century with its three-story brick buildings on the main streets. This view of the southeast corner of Main and Buffalo Streets shows the large brick B. M. Fish Dry Goods Store, the Buffalo House with its extended second-floor balcony, and the brick building that served over the years as Hamburg's jail, village headquarters, and volunteer fire department.

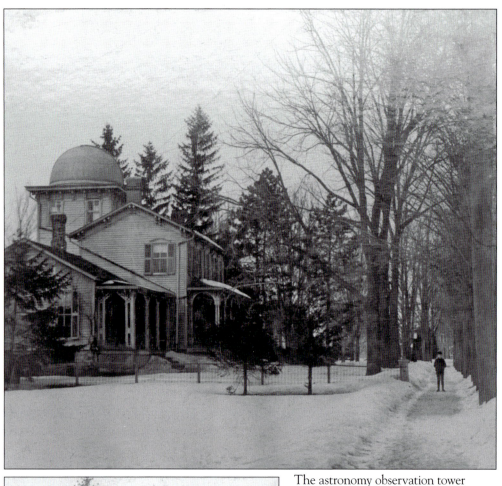

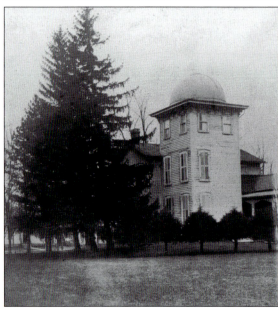

The astronomy observation tower was built in 1874 and was designed and constructed onto the home of Milford Fish by a mechanical engineer named George Walker. These views from about 1908 show this wonderful observatory and the house that stood on the corner of Buffalo and Union Streets. The big telescope had many moveable parts with a 9-inch glass that could be moved to any position. There was a sliding door in the dome, and the entire dome revolved. The platform under the telescope itself could be raised or lowered. Burton M. Fish was known and admired as Hamburg's astronomer. After the observatory was dismantled, this house was moved twice: once to a different place on the same lot and finally to East Prospect Avenue.

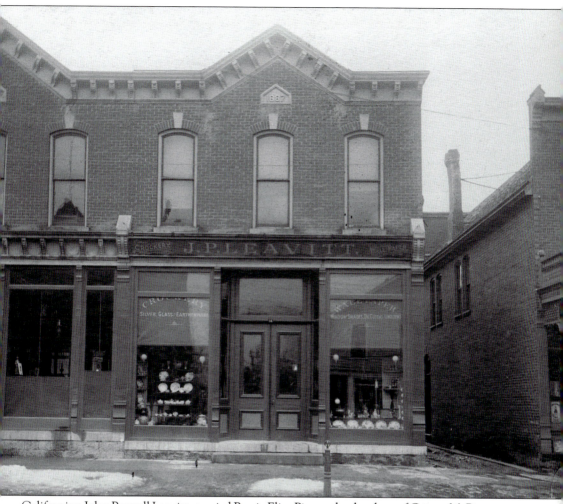

Californian John Pennell Leavitt married Bessie Eliza Pierce, the daughter of George M. Pierce, on June 19, 1900, and operated a crockery and wallpaper store in the western end of the Kronenberg and Fish Store on Main Street. Leavitt was a brother-in-law of William Kronenberg, who had married Bessie's sister Louise. The Leavitts had a son, Pierce, and three daughters, Ruth, Dorothy, and Marion. The family moved from Hamburg to Puyallup, Washington, in 1906. After a visit to Hamburg, the Leavitts were boarding a train in Buffalo, when John P. Leavitt collapsed as he was handing the tickets to the conductor. He died on August 8, 1919. (Courtesy Hamburg Historical Society.)

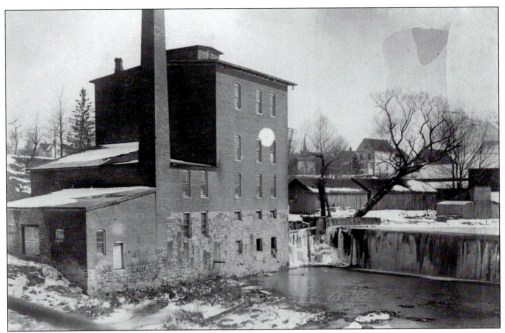

The early settlement of White's Corners developed near Eighteen Mile Creek, and early mills used waterpower to grind grain into flour. John Schoepflin started his mill in 1826, and his mill was rebuilt in 1856 and 1877. By 1913, the mill was this three-story brick structure that could produce 75 barrels of roller flour and winter wheat per day.

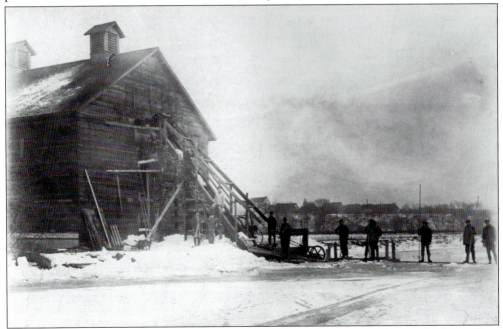

This icehouse stood above the dam on Eighteen Mile Creek near Schoepflin's Mill, about where South Buffalo Street is today. The photograph shows workmen holding poles and the conveyor that would lift chunks of ice from the creek into the icehouse to store it for warmer months ahead. (Courtesy Hamburg Historical Society.)

This iron bridge crossed Eighteen Mile Creek at the foot of South Buffalo Street near Schoepflin's Mill en route to East Eden. This bridge was replaced with a concrete bridge, east of this old one. The concrete bridge that replaced this iron bridge was called "Abbott's Bridge" after George Burwell Abbott, who served as head of the Erie County Highway Department.

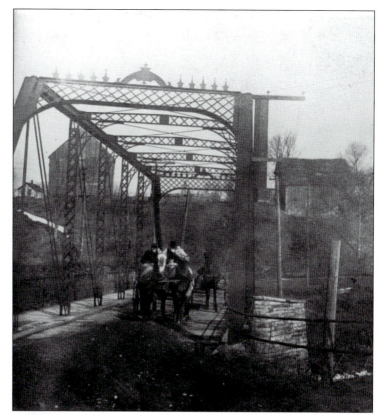

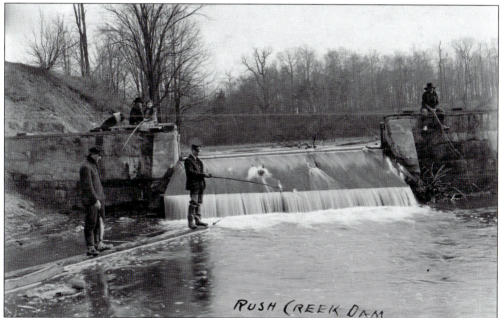

Hamburg has several creeks running to Lake Erie, including Rush Creek south of Blasdell. This photograph from about 1905 shows fishermen at the dam on Rush Creek. Like Eighteen Mile Creek, there are sections of Rush Creek that cut through shale beds that are rich in fossils.

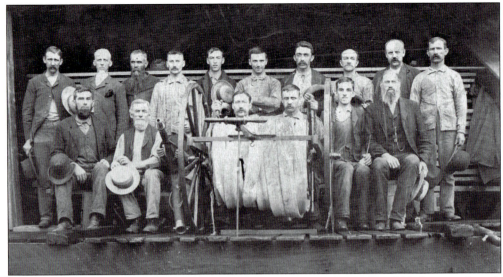

Sixteen members of the Hamburg Volunteer Fire Department pose in this 1890 photograph with one of their two-wheel horse carts that were hauled by hand to a fire. These four carts were located in different places around the village, behind Carlton Eno's grocery store, near the Village Park, in the middle of Main Street, and north of Main Street. (Courtesy Hamburg Historical Society.)

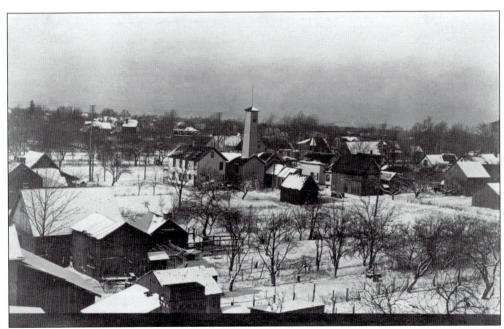

This 1908 photograph was taken from the cupola of the Brendel Building, and it shows Main Street backyards and a group of structures on Center Street including the jail and the firehouse. After a fire, wet hoses were hung in the tall tower to dry. In 1897, the fire department had funds to purchase a site on Center Street and to construct a building to store fire apparatus here.

The cornerstone of Hamburg's Triumph Lodge No. 712 of the Independent Order of Odd Fellows was laid on August 1, 1914. Alexander C. Parks was called the "Builder of the Temple" because he was the leading fund-raiser for this project. The 1914 temple was designed by architect Lawrence Bley in a neoclassical style, and it was constructed on Buffalo Street. This important landmark was a great gathering place for Hamburg social events but was demolished in 1966. (Courtesy Hamburg Town Historian.)

The Odd Fellows Temple was a landmark on Buffalo Street from 1914 to 1966 when the Hamburg Lodge closed and remaining members joined the Orchard Park Lodge. This photograph shows the stately temple, with the symbols for friendship, love, and truth on the pediment as well as the observatory of Milford Fish to the right. (Courtesy Hamburg Town Historian, Guenther Photograph Collection.)

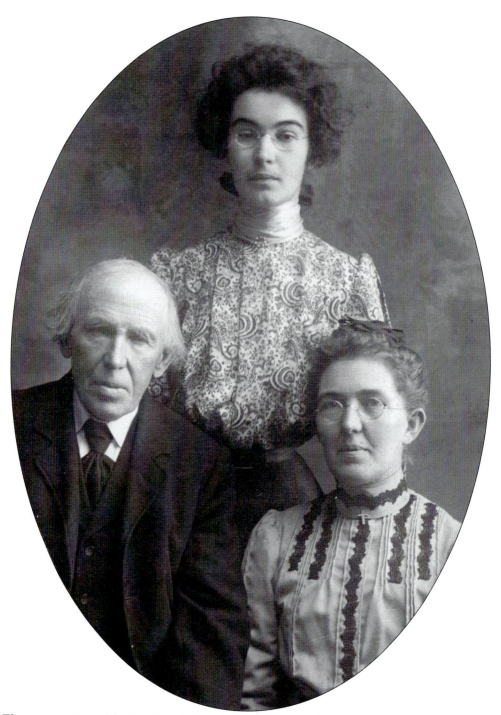

Three generations of the Vogel family included, from left to right, Henry Vogel; his granddaughter Mayme Schwert; and her mother, Mary Vogel. Mary was widowed, and she raised her six daughters at 93 Pine Street. Mayme and her husband, Marvin Schwert, lived at 31 Union Street. This house was moved next door when the Hamburg Public Library built a parking lot and exit onto Union Street in the 1960s. (Courtesy David Pound.)

Conrad and Magdalena Ballard Danheiser operated the Danheiser Hotel on West Union Street. Conrad worked as a real estate agent in addition to running the hotel. Magdalena, or "Lena," had a family of four sons—Joseph, Albert, Frank, and Louie—and four daughters—Elizabeth, Matilda, Lillian, and Clara. Clara was known in religious life as Sister Antonella. After 1913, the Drummer Hotel was moved across the street and connected to the Danheiser Hotel. (Courtesy Robert Dossinger.)

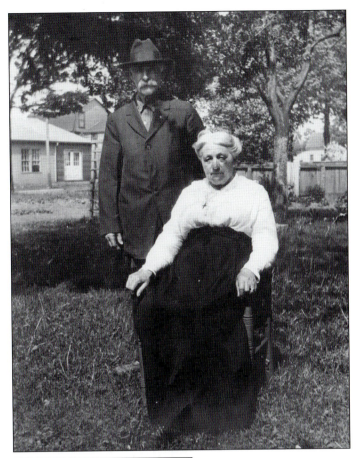

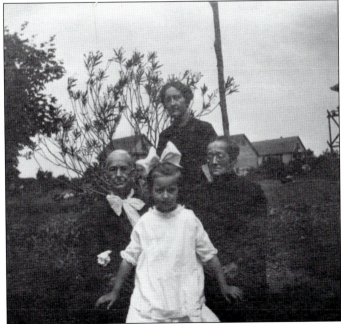

Four generations of the Rudloff, Schieber, and Danheiser women are shown in this 1911 photograph. Evelyn Dossinger stands in front of her great-grandmother Anna Rudloff and her grandmother Elizabeth Rudloff Schieber. Evelyn's mother, Anna Schieber Danheiser, stands behind her grandmother and mother. Anna Danheiser was married to Frank Danheiser who worked as a tinsmith and plumber. Frank's father, Conrad Danheiser, operated the Danheiser Hotel on West Union Street. (Courtesy Robert Dossinger.)

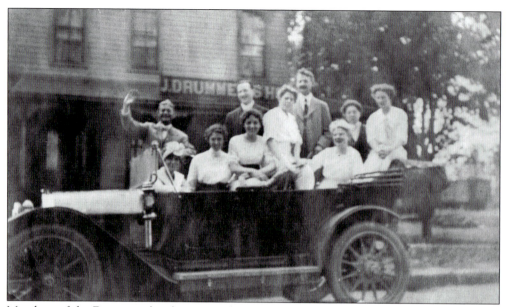

Members of the Drummer family pose in their new convertible automobile in front of Joseph Drummer's Hotel on West Union Street in 1902. This photograph shows Joseph Drummer and his daughter Frances in the backseat of the automobile with Emma Drummer Fox behind her with Joseph Drummer Jr., standing at right. (Courtesy Hamburg Town Historian.)

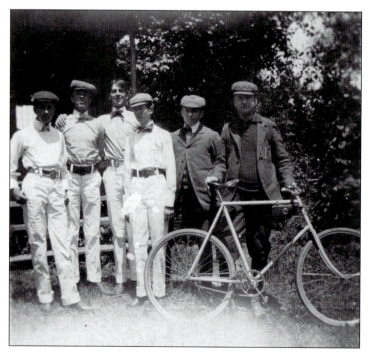

Bicycles were popular for transportation in the late 1890s, and these Hamburg young men had one on their vacation. From left to right are Clarence Bartholomew, Ray Spencer, Glenn Bunting, Seaton Newell, Charlie Bourne, and Oddie Duel. Charlie Bourne grew up to be a noted village physician and married Martha Wheelock. Ray Spencer was the son of Harvey S. Spencer, cashier of the Bank of Hamburg. (Courtesy Kathy Rice.)

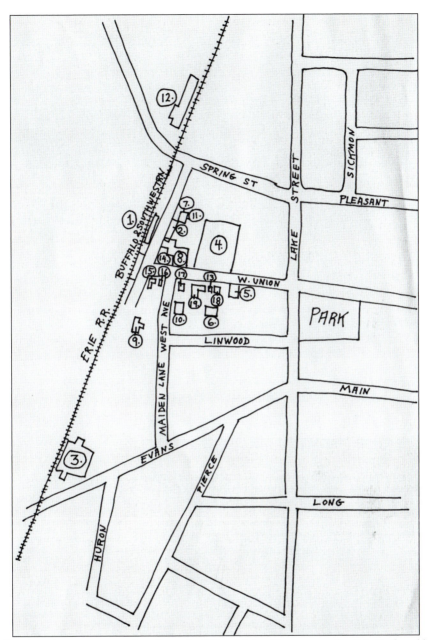

Many Hamburg businesses stood at the end of West Union Street near the Erie Railroad lines. 1) The 1897 Freight Station; 2) The 1902 coal yard of Henry Michael had a track for a coal handcart that connected it to the main railroad line; 3) The Hamburg Canning Company. It had a 12-foot-deep well and areas for fruit storage and tin can storage; 4) The Hamburg Planing Mill for lumber and decorative millwork; 5) David Frazer horse collar factory; 6) E. C. Hubbard Fruit Evaporator; 7) 1913 foundry of H. Baltser; 8) T. H. Richardson Feed Mill; 9) 1902 N. L. Millar Planing Mill; 10) 1897 coal warehouse; 11) F. R. Atkinson Spring Company; 12) 1929 glass casting factory; 13) 1902 icehouse; 14) 1897 Union Hotel; 15) 1913 Drummer Hotel; 16) 1907 livery; 17) 1913 coal office; 18) 1902 hotel; 19) 1913 Danheiser Hotel. Spring Street is now called Pleasant Avenue, and Maiden Lane is now called West Avenue.

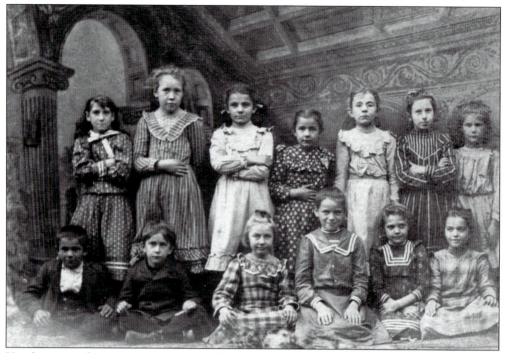

Hamburg was always a wonderful place for children to live. This photograph from about 1905 shows a group of 11 girls and two boys who were pupils at Saints Peter and Paul School dressed in their best clothing. Many children have strong ethnic features and family resemblances to one another. The architectural elements behind the children are painted on a photographer's cloth backdrop.

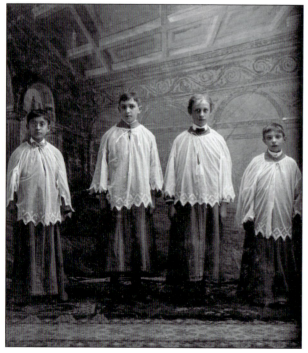

Four altar boys from Saints Peter and Paul Roman Catholic Church are, from left to right, George Moritz, Louis Thum, Clarence Koch, and Ray Thum. Louis and Ray Thum were brothers and lived near the church at 79 East Main Street. Their father, Louis Thum, was a wood engraver who created advertising art. George Moritz later became a wagon driver delivering groceries, and his father Leopold Moritz was a blacksmith.

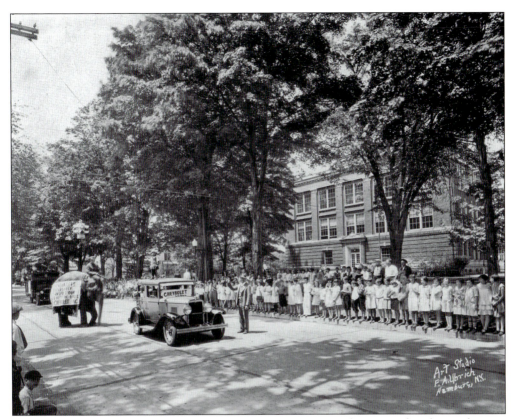

Hamburg has had plenty of parades, including this one from the 1920s that featured a new Chevrolet and a real live elephant that walked down Union Street in front of the Hamburg Grade School. Boys and girls have left their classrooms and lined Union Street to enjoy the spectacle that included a costumed child standing on the flat roof of the moving Chevrolet.

Halloween was a huge celebration for Hamburg children and included parties and parades. In the 1930s, the school principal served as the grand marshal of the Halloween parades. This photograph shows the 1934 kindergarten class of the Hamburg Grade School, and the disguises include a pirate, Red Riding Hood, and a clown, but the picture is dominated by the child dressed as a "Black Mammy."

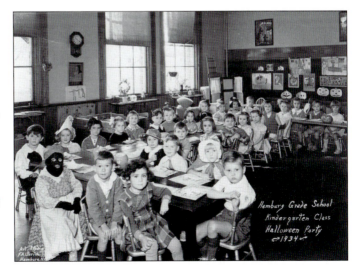

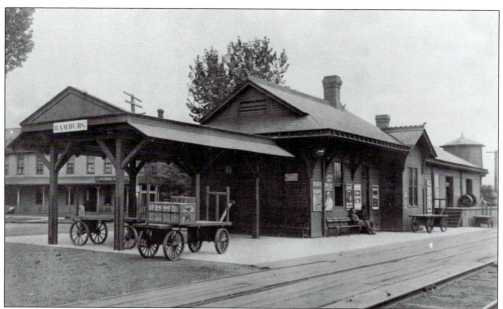

The Erie Railroad station was constructed about 1890 at the foot of West Union Street, in the section of Hamburg that had a variety of industries and hotels. This building was the second station erected for the Erie Railroad, and it served both freight and passengers until a separate passenger station was constructed at Pleasant Avenue in 1921. The Drummer Hotel can be seen in this photograph behind the station.

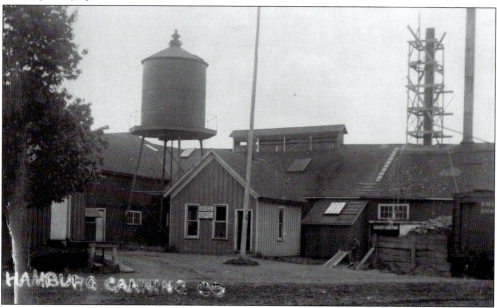

The Hamburg Canning Company was incorporated in 1881 by George M. Pierce and Thomas L. Bunting. This company employed over 200 people, and they processed and packed the fruits, vegetables, and meats from area farms. This business had factories in Eden and Akron, New York. When a shipment of produce arrived at the factory, the foreman would blow a horn, and workers living in the vicinity would come and work at the cannery. The canning company closed on November 5, 1943.

Three

THE MANY WAYS OF HAVING FUN IN HAMBURG

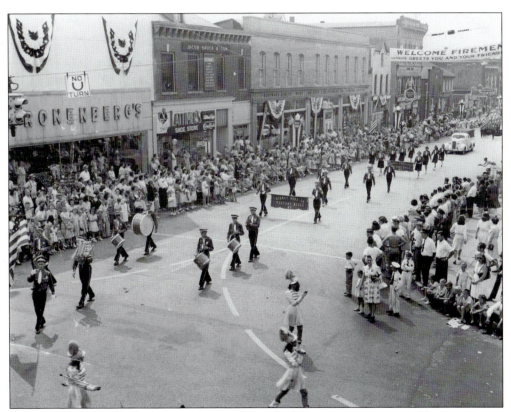

Hamburg has been the place for people to gather and celebrate many occasions. The Erie County Fair has brought people to Hamburg since 1868, and the five-day-long "Old Home Days" centennial celebration of 1912 brought record crowds here. This photograph shows the Southwestern Volunteer Fire Association parade that was held on August 8, 1947. (Courtesy Hamburg Town Historian.)

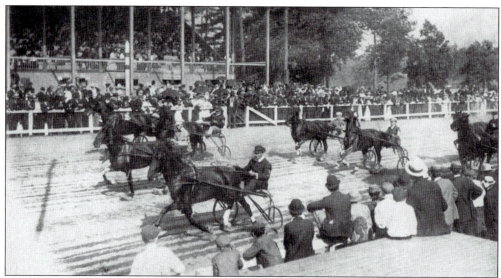

Early agricultural fairs were held in Buffalo as early as 1820. The Erie County Fair has been held in Hamburg since 1868. The Hamburg location was selected partly because of a racetrack that was available on the property of Luther Titus. This picture, from a 1909 Erie County Fair Premium Book, shows the excitement of horse races in front of the old grandstand. (Courtesy Mr. and Mrs. Jimmy Barrett.)

Erie County Fair at Hamburg, N. Y., Sept. 7-8 9-10, 1909.

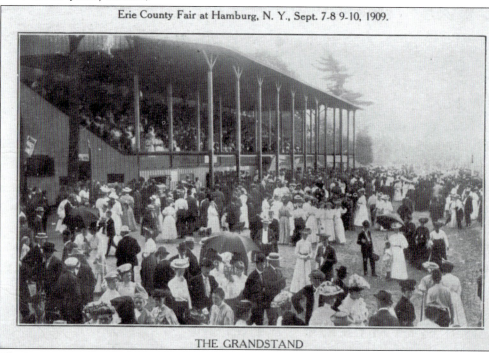

THE GRANDSTAND

The Erie County Fair was held for four days, from September 7 until September 10, 1909, and advertisements offered "exciting horse races, a grand tournament, large exhibits, reduced rates and special trains." This postcard shows the first grandstand that was built in 1884 and could hold 1,200 people. Visitors came elegantly dressed. Men wore suits, and ladies wore lovely dresses and large, attractive bonnets.

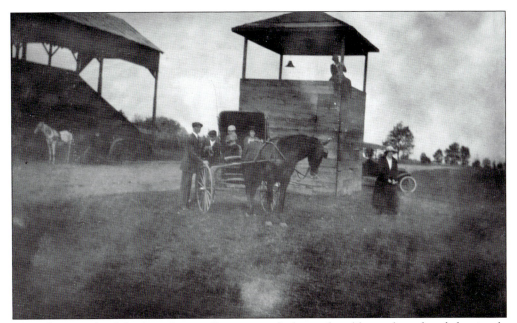

This photograph of the Erie County Fair racetrack shows the old grandstand and the simple elevated platform where judges could stand to view the finish line and determine the winner of a horse race. The fairgrounds had 80 box stalls and provided hay, straw, and stabling for horses that ran in the races. In 1909, prize purses were $300, and rules of the National Trotting Association determined the winners. (Courtesy Mr. and Mrs. Jimmy Barrett.)

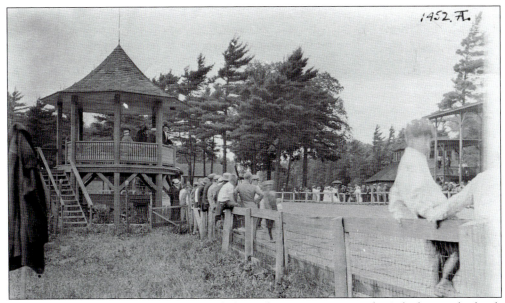

This view of the Erie County Fair racetrack shows the attractive, new judges' platform at the finish line. The Octagon Building, constructed in 1885, and the grandstand are seen at right.

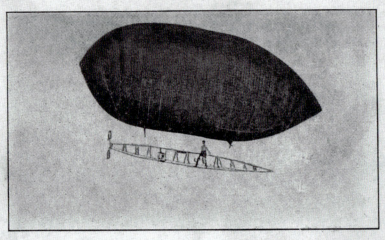

Erie County Fair at Hamburg, N. Y. Sept. 2-3-4-5-6, 1907.

FREE ATTRACTION—The great sensation of the age—A Real Flying Air Ship. Prof. Van Vranken, the most successful operator before the public will make an ascension each day at the Erie County Fair, Hamburg, N. Y.

The Erie County Fair showed spectacles beyond the crafts, animals, and produce exhibits. In 1907, fair visitors could see "the great sensation of the age, a real flying air ship," piloted by Prof. Von Vranken who made his ascension each day from September 3 to September 6. In 1889, visitors could witness a Grand Balloon Ascension and Parachute Drop, advertised as a Grand Spectacle.

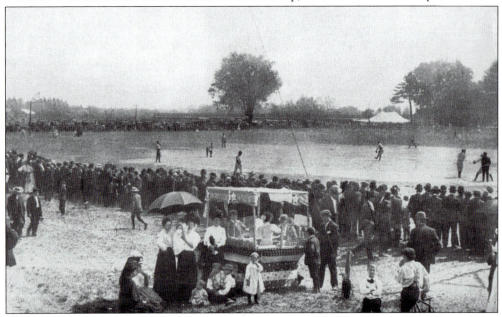

Men and boys gathered for the grand baseball tournament at the 1909 Erie County Fair. This tradition continued, and games were held on a diamond in the center of the racetrack. A young lady operated the refreshments stand. The Women's Christian Temperance Union worked to have alcoholic beverages banned from the Erie County Fair in 1887. The diagonal line in this picture appears to be the line of the airship tethered to the ground. (Courtesy Mr. and Mrs. Jimmy Barrett.)

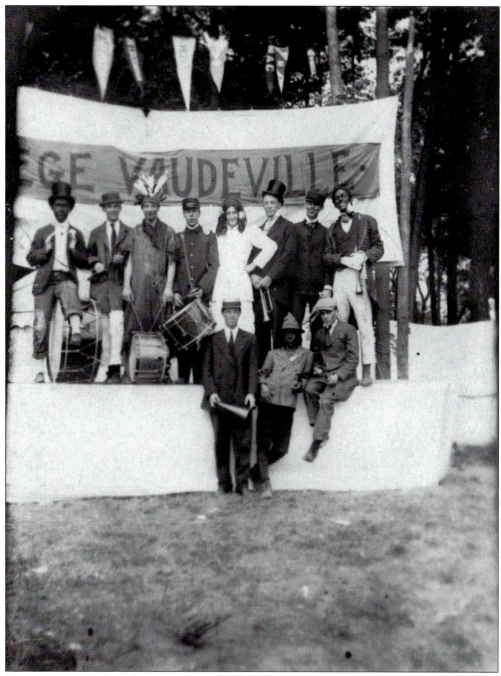

George Francis Abbott (1887–1995) and his friends presented an amateur musical event called "College Vaudeville" at the 1909 Erie County Fair. This remarkable theatrical producer graduated from the Hamburg Academy in 1907 and became known as "Mr. Broadway" for his work in musicals including *Porgy and Bess*. Abbott's friends who appear in costumes with him on this rudimentary stage include Mickey Abbott, Harold Jarvis, Fred Hauck, Amos Minkel, Kenneth Federspiel, Elisha Thurston, and Walter Purcell. (Courtesy Carl Kunz.)

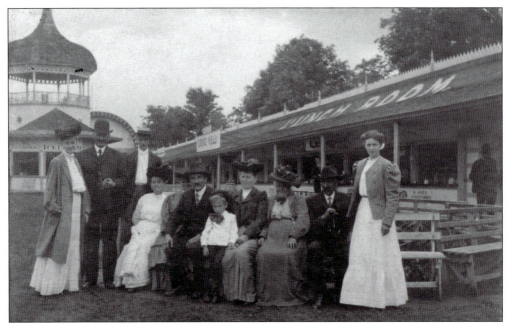

In many ways, the Erie County Fair has changed over the years, but many of the basic foundations of good food, good displays, and good entertainment have remained the same. This photograph from about 1910 of the open-air lunchroom shows the elegant and formal attire visitors wore at the fair.

A strong women's department guaranteed that the Erie County Fair would be enjoyable and interesting for ladies. This photograph from 1902 shows examples of fancy needlework that demonstrated women's talents. In 1909, the women's department was run by Mrs. W. C. Froehley, Mrs. H. G. Parker, Mrs. Fred Pierce, Mrs. Robert Gunn, and Mrs. Edward M. Adams. (Courtesy David Pound.)

While men had baseball games and horse races, women could enter their quilts, afghans, flowers, jams, and jellies and know that other women who visited the women's department would admire their accomplishments. (Courtesy Hamburg Town Historian.)

Bill and Mildred Miller broadcasted their daily television program *Meet the Millers* from the Erie County Fair and interviewed Don Ameche who brought his International Showtime Circus to Hamburg. His circus acts included the French aerialist Mademoiselle Jeannine Pivoteau; the Goddess of Flight, Princess Taina; a musical seal; and Borjeva, a comedian who performed while spinning 33 plates on rods. (Courtesy Hamburg Town Historian.)

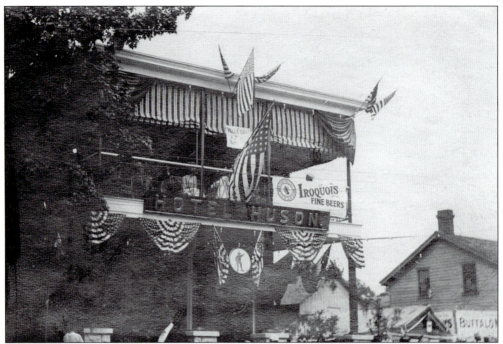

The town of Hamburg celebrated its centennial with a week of festivities beginning July 21, 1912. Religious services were held on Sunday to commemorate the founding of the town in 1812. Monday was "Reception Day" and speeches were given by Rev. Ward Platt and newspaper editor Frank Walker. Tuesday was "Sports Day" with races and baseball games. Wednesday was "Fraternal Day" with a huge parade and the firemen's banquet.

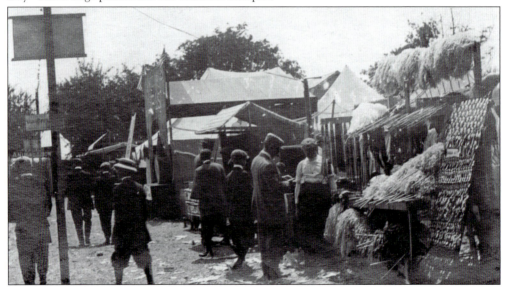

Many vendors, barkers, and peddlers sold their wares along Main Street during Old Home Week, and there were many activities for visitors along the streets for the five days. Festivities included comedy acrobats, trained dogs, a musical merry-go-round, and a high-wire act. Trains brought thousands of visitors to Hamburg all week; a special train left Buffalo every 10 minutes beginning at 5:30 am.

Old Home Week parades were remarkable. The Firemen's Parade had 23 bands, and 2,200 people marched in 74 companies past 2 miles of densely packed spectators. The Fraternal Parade had eight carriages of Civil War veterans escorted by 50 Boy Scouts. Hamburg's old-timers, including John Ueblacher, John Feth, and John Neussle rode in an old rig drawn by a 40-year-old mule, as the original town supervisors had done 100 years before.

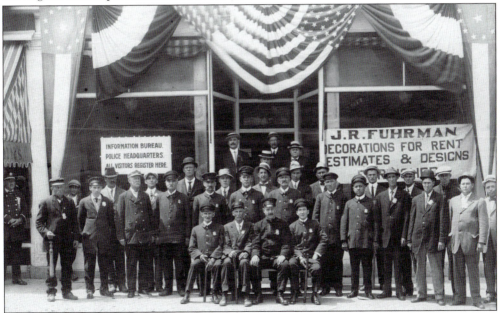

George L. Pomeroy, Carlton E. Eno, Frank Ueblacher, and Daniel C. Pierce had planned Old Home Week, and they knew that strong security was needed to manage the throngs of visitors and the revelry that lasted until midnight each night. Walter B. Hammond and police chief J. W. Rogers led 20 men, 11 deputy sheriffs, and 2 detectives from Buffalo police headquarters to maintain order. (Courtesy Hamburg Historical Society, Harriet Fitzgerald Collection.)

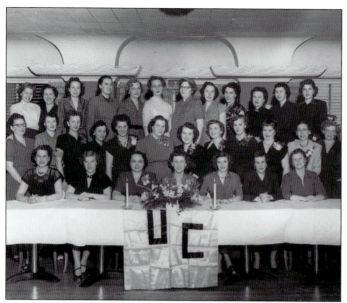

At the turn of the 20th century, women's clubs were formed around the country and Hamburg had its share of them. The Hamburg Women's Club was organized in 1919, and it branched out into the garden club, the parent-teacher association, the league of women voters, and the antiques study group. This photograph shows the Utopian club members, formed in 1931. This group aspired to gather together Hamburg women to "do what they could for the community." (Courtesy Hamburg Town Historian.)

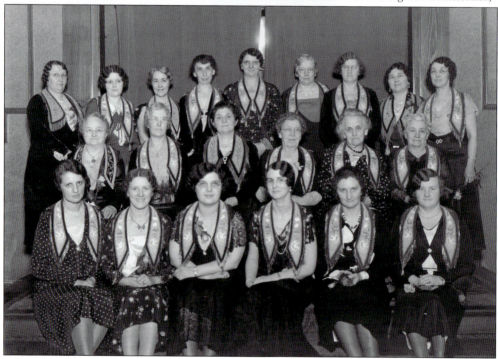

Hamburg's Beulah Chapter of the Order of the Eastern Star was organized on May 11, 1899, as a lodge for female relatives of Master Masons. This chapter was named after Beulah Newton, daughter of Hamburg pioneer and lawyer Abram Thorn. From left to right are (first row) Lydia Dent, Clara Clark, Lorna Pierce Johnson, Pearl Kleis Gates, Etta Veger, and Minnie Fowles; (second row) Mrs. Kaehm, Bertha Craig, Mrs. Charles Zimmerman, Emma Kopenhafer, Anna Meyers, and Bella Mohr; (third row) Lena Velzy, Hazel Seeger, Zelica Schaus, Clara Lawrence, Louise Horni, Lula Knoche, Lottie Smith, Mary Haas, and unidentified. (Courtesy Hamburg Historical Society.)

The Hamburg Antiques Study Group was formed in 1955 as an offshoot of the Hamburg Women's Club. The group began an annual antiques show in 1956, and this event in May 1958 was held at the Masonic Temple and featured a display of antique needlework samplers from the Whitman Candy Company. From left to right are (first row) Grace Magee, Gertrude Doyle, Margaret Lafey, and Dorothy Mulholland; (second row) Phyllis Thompson, Marguerite Bourne, Dorothea Alexander, Verna Meyers, Josephine Rosinski, Alice Miller, Evelyn Thomas, Louise Stark, Mrs. William Hind, Helen Murray, Isabel Toone, and Mrs. Charles Rose. (Courtesy Hamburg Antiques Study Group.)

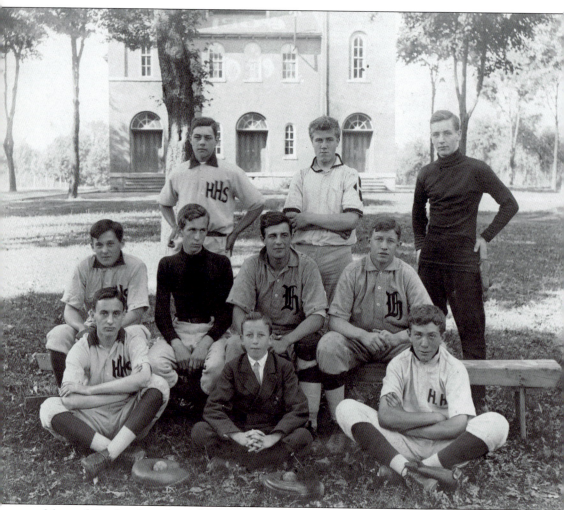

Many of Hamburg's student athletes became community leaders. Hamburg High School's 1908 championship baseball team included, from left to right, (first row) Ray Bush, mascot Elton R. Heath, and Al Stokes; (second row) Ray Bley, Art Straub, Conde Bley, and Fred Stein; (third row) William Finkbinder, Courtney Hammond, and Amos Minkel. Minkel served in World War I and became a well-known village physician. Elton R. Heath wrote his recollections of Hamburg, *Around Old Hamburg Village at the Turn of the Century: a guided tour*, in 1982 and presented slide talks about Hamburg history. Fred Stein became a well-known baseball player but died young following a burst appendix. (Courtesy Hamburg Historical Society.)

The Hamburg Star Baseball Club became champions of Western New York baseball teams in 1901. The following are, from left to right: (first row) ? Freeze and ? Spittler from North Evans; (second row) Ray Whiting, John Metz, manager Roy Ingersoll, Frank Schummer, and Charles B. Kronenberg; (third row) Hayes Ingersoll and Walter Taylor; (fourth row) Alton Wheelock, Harold Cook, and James Scoville. (Courtesy Hamburg Historical Society.)

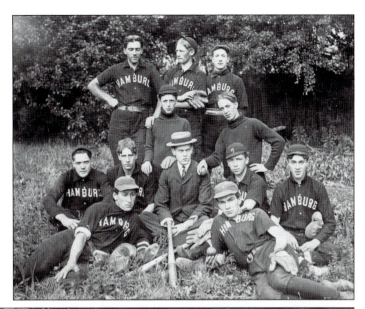

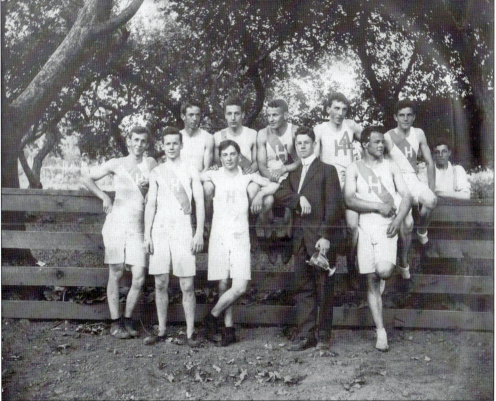

The Hamburg High School Track Team of 1909 had notable members also. From left to right are Arthur Straub; Maynard Bensley; Ben Brocksopp; Clarence Henry; Amos Minkel; Clinton Abbott; Paul Schoepflin, holding cup; Arthur Knapp, the best miler in Hamburg; Edgar Nye Salisbury, best shot-putter in Hamburg; John Macmillon; and Ray Brocksopp. Edgar Nye Salisbury was the son of John W. Salisbury. (Courtesy Hamburg Historical Society.)

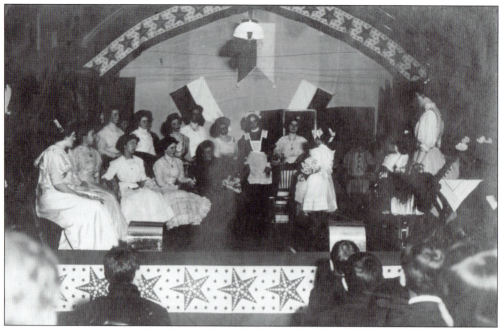

Hamburg has had many theaters for musical performances, dramas, reviews, and films. George Kopp was born in Ranschback, Bavaria. He married Juliana Berlenbach and built a tavern at White's Corners in 1857. John W. Salisbury's Grange Building has an attractive stage and theater on the third floor. This photograph shows a theatrical review performed by the women of Saints Peter and Paul Parish.

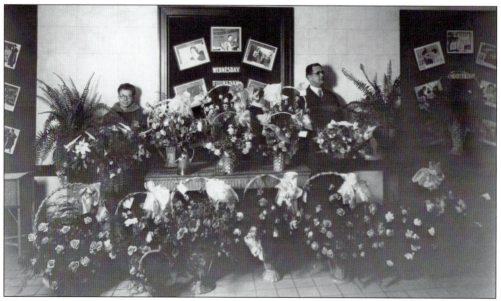

George J. Biehler received many bouquets from well-wishers when the new Palace Theater was opened on Buffalo Street on January 14, 1926. This theater replaced the old Palace across Buffalo Street and was designed by architect Lawrence Bley. Hamburg Village also had the Gem Theater managed by Henri deVerneuil and a moving picture show in the first floor of the Dietrich Building at 60 Main Street. (Courtesy Arlene and Michael Biehler.)

Hamburg Little Theatre began in 1948 under the leadership of Maurice G. Bley who had experience with the Studio Theatre of Buffalo and the Catholic Theatre Guild. Before this, the Hamburg Players presented a large historical pageant called "Wakefield" in 1932. In this photograph from 1954, director Maurice Bley directs Peter Danforth and Barbara Meyer as Mrs. Robert Ulrich and William Thayer work on the set. (Courtesy Hamburg Town Historian.)

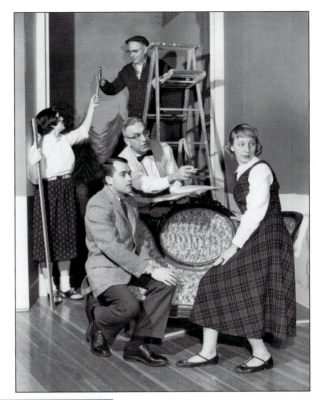

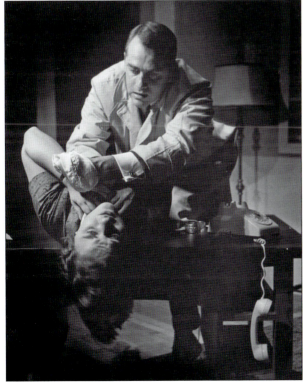

Hamburg Little Theatre players Peter M. Danforth and his wife, Rose Stevanoff Danforth, added extra realism to the murder scene of the play *Dial M for Murder*, which was performed at Hamburg High School in November 1960. (Courtesy Rose S. Danforth.)

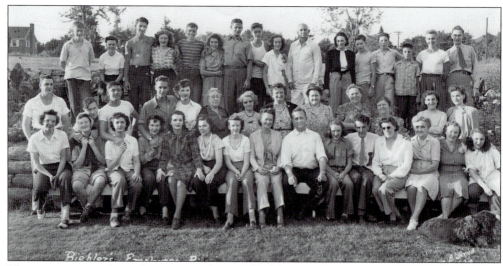

This group portrait shows the many employees of Biehler's Tea Room, Palace Theater, and Biehler's dairy who attended the annual picnic at the Biehler home in August 1946. From left to right are (first row) Laura Schall, Mary Sullivan Orr, Natalie Schutts Gaylord, Ann Zolk, Helen Parish, Gert Welsted, Kathleen Sullivan Cornell, Evelyn Biehler, Norman Biehler, Rosemary Asbury, Larry Bauer, Aylene Edie, Mrs. Gould, Cleo Mack, and unidentified; (second row) Harry Smith, John Stachera, Scott Strachen, Norm Biehler Jr., Rosemary Shu DuBois, unidentified, Florence Mumbach, Frances, Bertha Sullivan, Mrs. Wittmeyer, Mrs. Wittman, Miss Wittmeyer, Ann Borowski; (third row) Paul Sullivan, unidentified, Lloyd Schreiner, Ellen Sullivan Orr, Lloyd, Verna Wittmeyer Koester, Al Scheera, George Biehler, Marion Peters, Ralph Miller, Dolores Harvey, Billy Peters, Ralph Brock, Lee Peters, unidentified, and "Tarzan" Wood.

Biehler's Tea Room was built on Buffalo Street in 1920 next to Robert Hengerer's ice cream and tobacco shop, which was established earlier by Fred Baser.

Four

WAR AND REMEMBRANCE

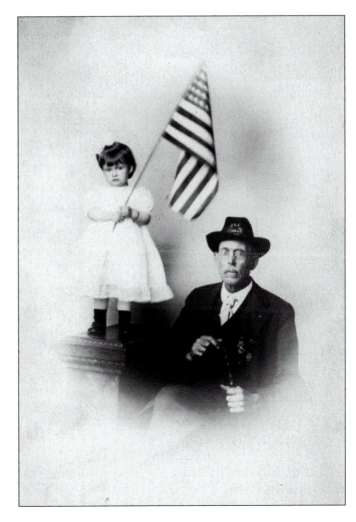

Many men from Hamburg fought in the Civil War, joining the 116th Regiment of New York State Volunteers in 1862. This photograph from 1914 shows Robert Taggert with his granddaughter Mary Ellen Cheesman. Theodore H. Gressman, Hamburg's last Civil War soldier, died on August 18, 1927, at age 87. (Courtesy Hamburg Town Historian.)

Four-hundred-seventy-three Hamburg men served in the Great War, or World War I, and 19 Gold Star Men lost their lives during that war. Communities across the nation celebrated when their soldiers and sailors came home, and Hamburg's "Welcome Home Day" was held on May 30, 1920. Doc Schoenwetter, Elsworth Saunders, Georges Altes, Ed Duchmann, and Hamburg children lined the road for the Welcome Home Day parade.

With their military service finished, Fred Schmidt, Albert Boehle, and Fred Miller pose in front of the Soldiers and Sailors Monument in the Hamburg Village Memorial Park on Welcome Home Day.

Proud mothers of soldiers and sailors who attended the Welcome Home Parade included Mrs. Haas, Mrs. Carrie Kirbis, Mrs. Mary K. Boehle, and Mrs. Baker. One mother carries her Blue Star Service Flag, the symbol that families displayed in a front window to show their sons were away at war. Mrs. John W. Salisbury had three sons who served in the war, and her son Edgar N. Salisbury died on April 6, 1919, at Fort Dix.

Valentine Ballard, cook of Company A, 308th Machine Gun Battalion; Howard A. Baltzer, Private, 6th Battery, Field Artillery; Albert H. Boehle, 1st Sergeant, Machine Gun School; and Dr. Amos Minkel, 1st Lieutenant, Base Hospital 98, stood at ease in Memorial Park on Welcome Home Day.

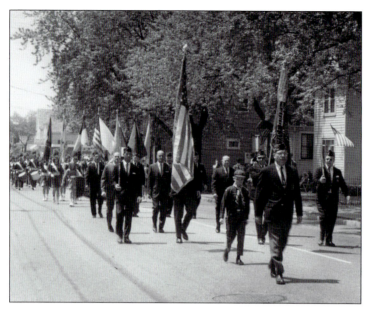

The Thomas E. Tehan American Legion Post No. 1449 and the Harry Clifton Post No. 60 organized the Memorial Day community parade on Lake Avenue in Blasdell in 1968. The Tehan Post was organized in 1946 and named after Thomas Tehan, a Marine who was awarded the Medal of Honor for service during World War II. Harry Clifton served as a private in Company K, 306th Infantry and lost his life in France on October 5, 1918.

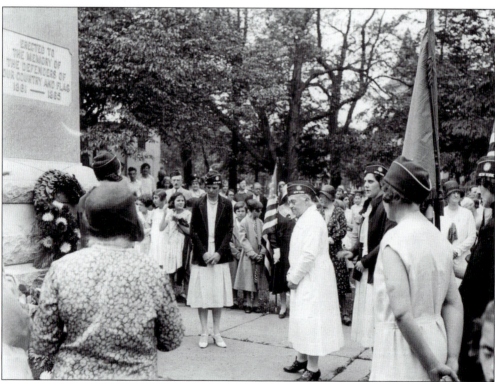

Hamburg women were responsible for building the Soldiers and Sailors Monument in Hamburg Memorial Park. When the monument was originally unveiled in 1914, a large delegation of Civil War veterans attended and members of the Women's Relief Corps of the N.J. Swift Post No. 32 parted large flags to reveal the bronze statue atop the granite monument. (Courtesy Hamburg Historical Society.)

Students and faculty of Blasdell schools gathered on April 30, 1945, to dedicate a blue spruce tree to the Gold Star Men and Pres. Franklin D. Roosevelt. Blasdell men who lost their lives in World War II include Harold Spencer, who died August 6, 1942, off the coast of Alaska; Harry Griffin, June 1, 1943, in the Newport Naval Hospital; Winford Ricks, January 29, 1944, on a bombing mission over Berlin; Edward D. Kern, May 12, 1944, in Germany; William Grinder, June 22, 1944, in Normandy, France; Thomas Stanes, June 28, 1944, in Saipan; Frank Mikos Jr., September 10, 1944, in France; Warren Longbine, October 28, 1944, in France; Robert Yaw, November 14, 1944, over the Atlantic Ocean; James Georgeski, December 2, 1944, in Italy; Chester Witkowski, December 11, 1944, at Leyte Island; Norman Schultz, January 4, 1945, in Belgium; Francis Goodchild, March 13, 1945, in Germany; Richard Stoops, March 7, 1945, in New Guinea; Alfred Hancock, March 27, 1945, in Germany; and Robert Greene, March 1945 at Iwo Jima. (Courtesy Hamburg Historical Society.)

Prospect Lawn Cemetery was organized in August 1878, when the old cemetery at Union and Lake Streets was becoming too crowded for the growing village. Graves and stones were removed and interred at Prospect Lawn from 1892 to 1893. The solid stone mausoleum shown at left was built in 1901 to hold the coffins of individuals who died during winter months, when the cemetery ground was frozen and graves could not be dug until a spring thaw. (Courtesy Hamburg Town Historian.)

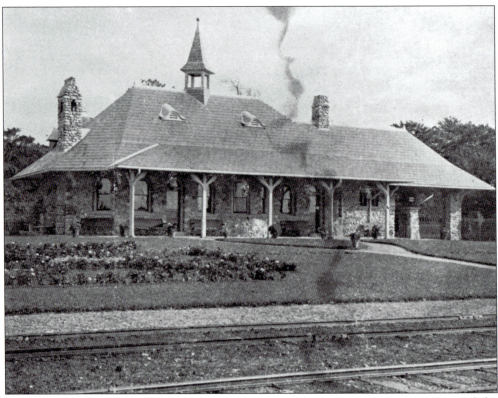

This photograph of the Lakeside Cemetery Station shows the stone cemetery office and the railroad tracks that could bring funeral trains out to Hamburg from the city of Buffalo in 1902. Lakeside advertised that a cemetery far from a city "precludes the danger of having to take up and re-inter the dead . . . a most distressing experience of lot holders of many Buffalo cemeteries." (Courtesy Hamburg Historical Society.)

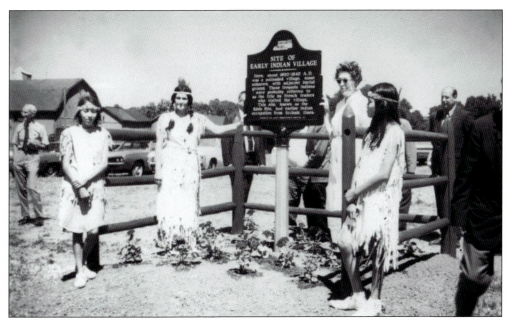

Native Americans lived in what is now Hamburg long before the white settlers came here. The Town of Hamburg erected a historic marker on June 12, 1971, at the site of an early Native American village from about 1620–1640. This settlement of Senecas left a burial ground that was known as the Kleis Site, excavated by the Buffalo Museum of Science. (Courtesy Hamburg Historical Society.)

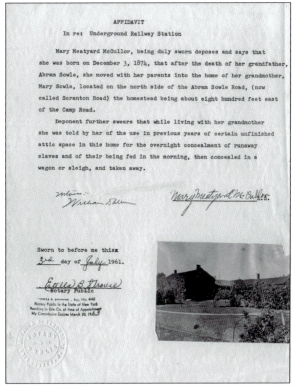

The Meatyard Homestead, a station on the Underground Railroad, stood on the old Abram Sowle Road, now Scranton Road. Mary Meatyard McCullor was born in 1874 and lived here with her grandmother Mary Sowle. Her grandmother told her the Meatyard home had a certain unfinished attic space that was used for overnight concealment of runaway slaves. (Courtesy Hamburg Historical Society.)

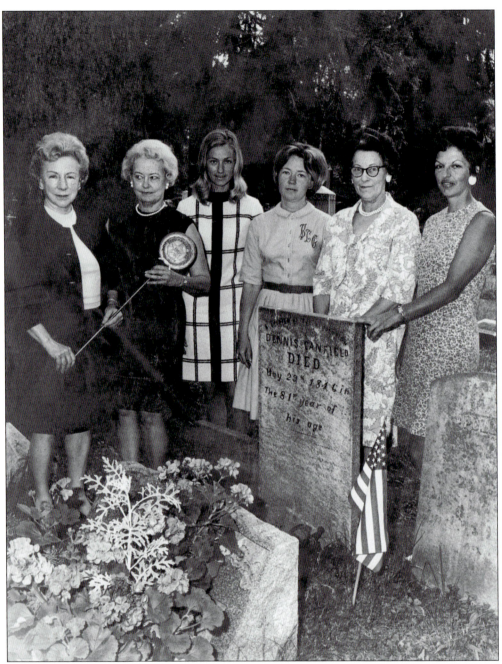

Two patriots of the American Revolutionary War, Dennis Canfield and John Dumbleton, are buried in Prospect Lawn Cemetery, and their graves were marked by the Daughters of the American Revolution in 1969. This photograph shows Mrs. Harry W. Learner, DAR Regent; Mrs. Burge Crocker; Mrs. Randall Frey; Mrs. John Griffin; Mrs. Sherwood (Marjorie) Sipprell; and Mrs. Norman (June) Zintz. (Courtesy Hamburg Historical Society.)

Five

OUT WITH THE OLD, IN WITH THE NEW

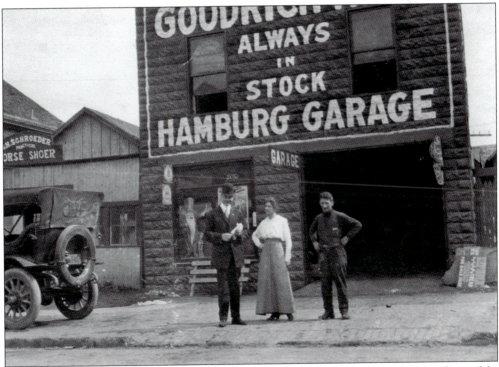

Many changes came to Hamburg at the dawn of the 20th century. Horse buggies were exchanged for automobiles and blacksmith shops became car repair shops. This photograph shows that the changes were gradual. The blacksmith shop of John H. Schroeder stood next to the Hamburg Garage on the south side of Main Street near Lake Street. The Hamburg Garage was formerly a harness shop next to the blacksmith shop. (Courtesy Hamburg Town Historian.)

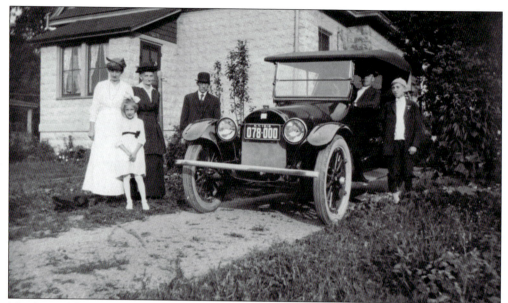

Members of the William Haberer family pose with their proud new possession, "our first Buick!" Hamburg had many different automobile dealerships. Chester Daetsch sold Dodges and Hudsons, Alvin Eschborn carried the Pontiacs, Donald Korst sold Chevrolets, Steffan Motors sold the Studebakers and Edsels, and Haberers eventually sold the Dodges and Plymouths. The Haberer family also built cement blockhouses like the one in this picture. (Courtesy Hamburg Historical Society.)

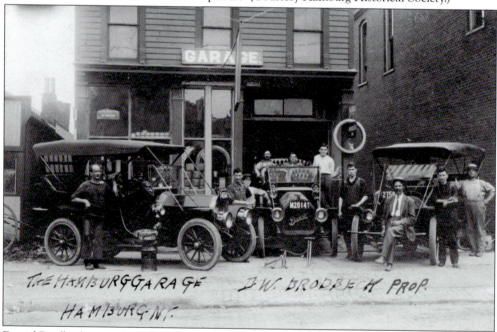

Daniel Brodbeck opened Hamburg's first automobile garage in 1912. In 1910, the *Industrial Recorder* (a magazine) of New York described him as "a striking illustration of the self-made man," starting a business on a small scale, and then expanding to a large and lucrative business." His employees included Chester Daetsch and Nick Schaus who worked as mechanic and blacksmith. (Courtesy Mr. and Mrs. Jimmy Barrett.)

Ernest Miller's blacksmith shop was born in Germany in 1876, and his blacksmith shop was located at 31 Center Street, near Main Street. This photograph shows Miller at left and another German blacksmith Rudolph Stratemeier at right. The blacksmiths' children did well; Viola Miller had a long career at the Hamburg Free Library and Albert Miller became an attorney. Henry J. Stratemeier served as village mayor from 1931 to 1935 and became a leading banker and Hamburg School Board president. (Courtesy Mr. and Mrs. Jimmy Barrett.)

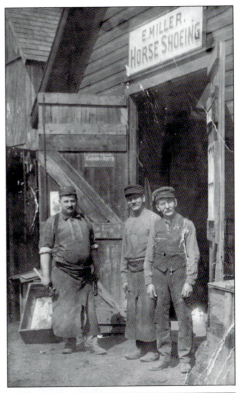

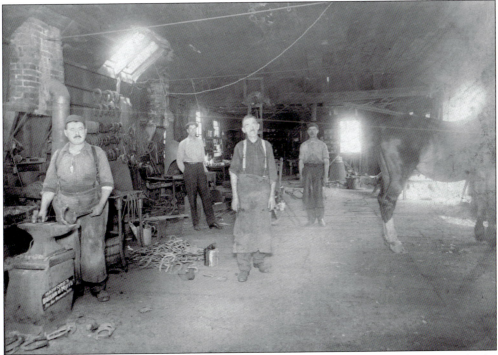

The interior of Ernest Miller's blacksmith shop on Center Street shows the tools of his trade: the anvil, a rack of horseshoes, and to the right, a horse. (Courtesy Hamburg Historical Society.)

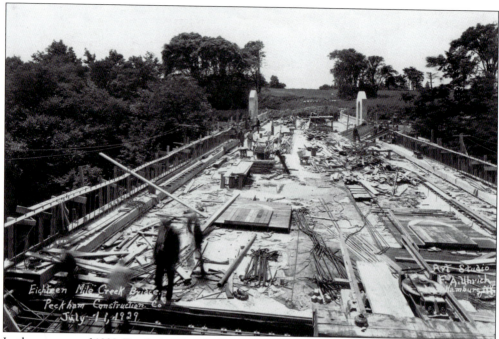

In the summer of 1929, Frank A. Uhrich photographed the construction of the Route 20 Bridge that spans Eighteen Mile Creek. Workmen used all wood scaffolding, and forms were made on site by about 20 carpenters who had no power tools. Now, Route 20 runs for 3,365 miles and is the longest road in the United States.

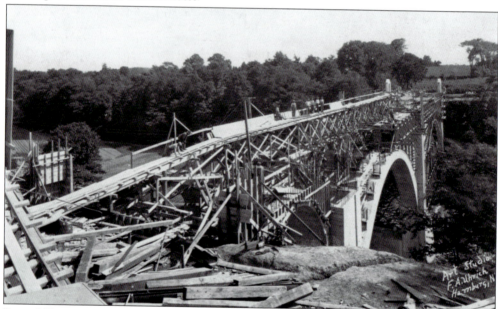

Route 20 brings many thousands of motorists through Hamburg. When the highway was widened, two additional lanes were added to this bridge by adding a cantilever on each side of this strong bridge. When the bridge was being constructed, the Shepeker Farm still had crops growing on their fields. The Shepard estate on the opposite side of the bridge was on land that became the Cliffside Inn.

The Hamburg Police Department was formed in 1915, and by 1923, they had two motorcycles and this patrol wagon. The police force consisted of Chief Fred Weiss, who often rode a bicycle, and Ferdinand Meyers and Maurice Mansfield. The Hamburg Garage stood on the south side of Main Street near Lake Street and was opened by Daniel Brodbeck in 1912. By 1920, this building became the home of Reifler Buick.

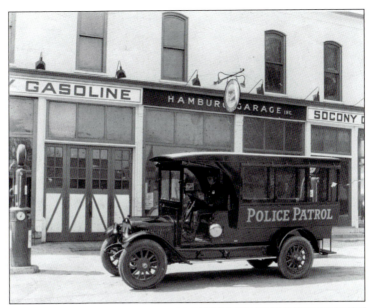

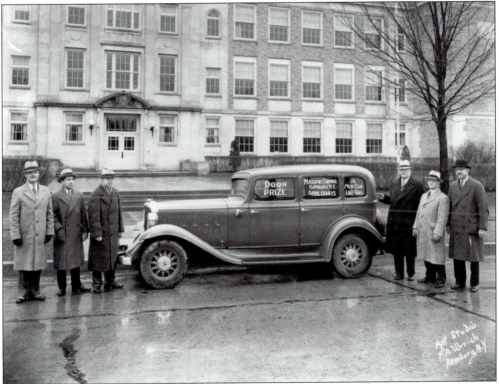

The 1932 Masonic Spring Carnival raffled this eight-cylinder Hudson sedan. The winner, G. Earl Partridge, had left the carnival early, asking a friend to come and wake him if he should win the Hudson automobile. Partridge did not believe it until Mayor Henry R. Stratemeier and Chester Daetsch, the Hudson dealer, drove into his yard and honked. From left to right are Hugh Dalziel, Lodge Master; Chester Daetsch; Eugene Highey; William Jenman; Allan Knapp; and Clarence Gerken. (Courtesy Hamburg Town Historian.)

Hamburg businesses have changed drastically from the first years of the 20th century. This photograph from about 1910 shows Bert Pound working in Jacob Hauck's shoe store on Main Street. Hauck later established his insurance business on the second floor of this building. Today this site touches the roundabout at Main and Buffalo Streets. (Courtesy David Pound.)

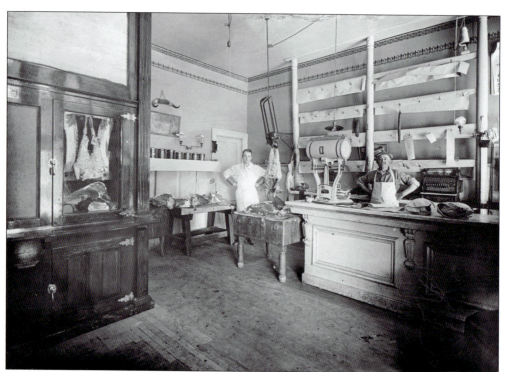

Karl Altes, standing at left, operated a meat market on Clinton Street in Buffalo before he purchased this Hamburg butcher shop that had been established by Andrew Stein before 1880. George Koelmel operated the business from 1891 until 1909, when the Altes family bought the business. George Altes, standing at right, and his sister Louise ran the shop from 1915 until 1952. (Courtesy Hamburg Historical Society.)

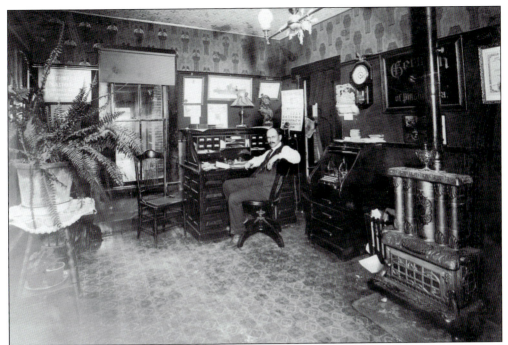

Joseph E. Leach was born in 1870 at the family home and office at 121 Main Street. He died in this same house on September 12, 1948, ending a 43-year career as Hamburg town clerk, believed to be the longest in the state. Leach held the office of town clerk since 1903, except for one term in 1910 when he lost to a Democratic candidate by one vote. (Courtesy Hamburg Historical Society.)

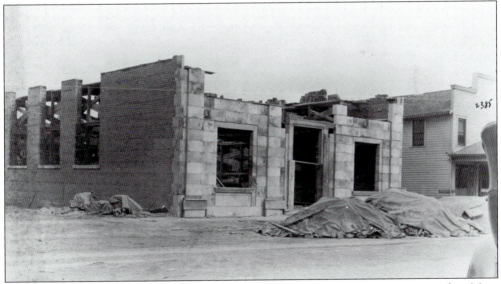

The Peoples Bank was first located in Kopp's building, then a new one was constructed on Main Street in 1904, and another was erected in 1906. The bank's first president was Amos H. Baker, then William G. Venner, followed by George A. Drummer and John W. Salisbury. This photograph shows the third Peoples Bank building being constructed on Main Street before it was opened July 1926. (Courtesy Hamburg Town Historian.)

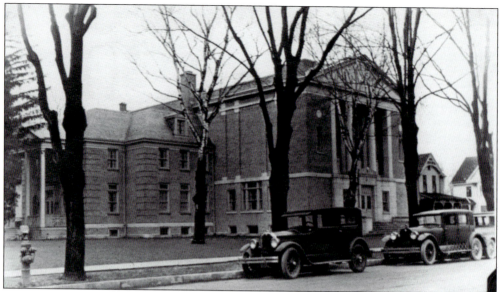

These two buildings were designed by Hamburg architect Frank A. Spangenberg. The Masonic temple on Buffalo Street was dedicated October 13, 1927, and it used the 1880 Victorian home of Jacob Peffer as part of the design. Spangenberg used neoclassical elements in his design of the new temple building, including the triangular pediment, the columns, and the pilasters on the facade. The old Hamburg High School on Pleasant Avenue has similarities, but it is designed for a different purpose. The Masonic temple had few windows, as it was a place for Masonic rituals and not open to the public. The high school building had walls of large windows to be filled with light for a large crowd of teenage students. Spangenberg designed this school structure in a new way; piers were constructed, and the building walls were said to be hung like curtains between the piers. The new high school building was opened November 12, 1925, and 1,500 people filled the auditorium for the dedication. (Courtesy Hamburg Historical Society.)

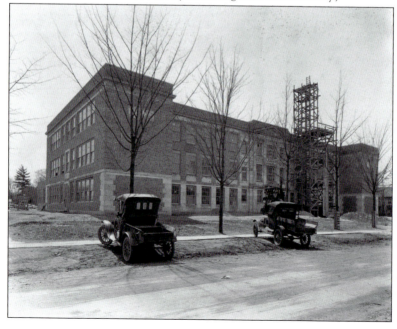

Six

GROWTH DURING THE BABY BOOM YEARS

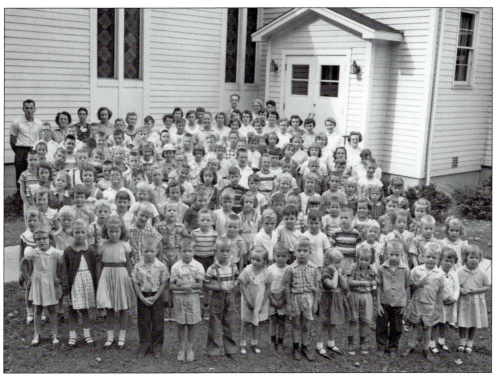

Over 77 million babies were born in the United States from 1946 to 1964. These young boys and girls outside the Grace Lutheran Church on Lake Street were some of the younger generation whose families would need new schools and homes throughout Hamburg. This church building was erected by the Freewill Baptists in 1846, and the Grace Lutheran congregation worshiped in this building from February 1950 until 1970. When this congregation grew, they constructed a new church on McKinley Parkway.

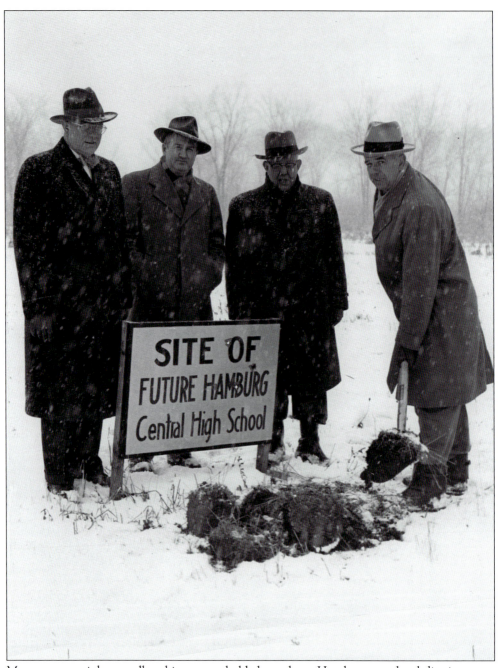

Many ceremonial groundbreakings were held throughout Hamburg as school districts were established and as new schools and offices were needed to serve the growing communities. Groundbreaking for the new Hamburg High School on Legion Drive took place on snowy February 5, 1954, with village mayor J. Leo Goodyear, high school principal Spencer W. Ravel, school superintendent W. Howard Vanderhoff, and school board president John W. Stovall. When the new school opened for the 1955–1956 academic year, the new structure could hold 800 students, and it featured 36 classrooms, a large swimming pool, and a gymnasium that seated 1,200 people. (Courtesy Hamburg Town Historian.)

Frontier Central Junior Senior High School was designed by architect Earl Martin, and ground was broken on January 23, 1954. This large facility required a 112-acre site and was part of a million-dollar bond issue. This photograph shows Frontier Central School Board president John W. Kleis kneeling to lay the cornerstone of the new school. (Courtesy Hamburg Historical Society.)

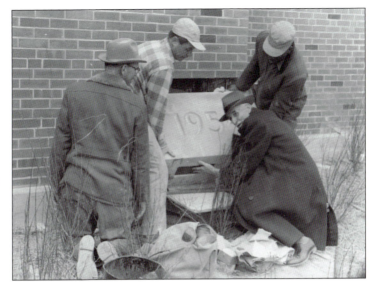

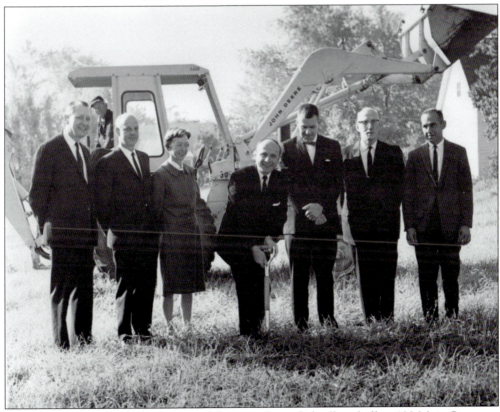

Hamburg village officials broke ground for a much needed village hall at 100 Main Street on land that had been acquired eight years before. The new Colonial-style building cost $220,000 to construct, and it was opened on November 14, 1974. Its new courtroom could be used for village meetings and seated 128 people. From left to right are Ed Hauck; Leon Lancaster, mayor from 1971 to 1975; Ella Newell; Joseph J. Castiglia; Jack Gilbert; and Frederick Sherwood. (Courtesy Hamburg Historical Society.)

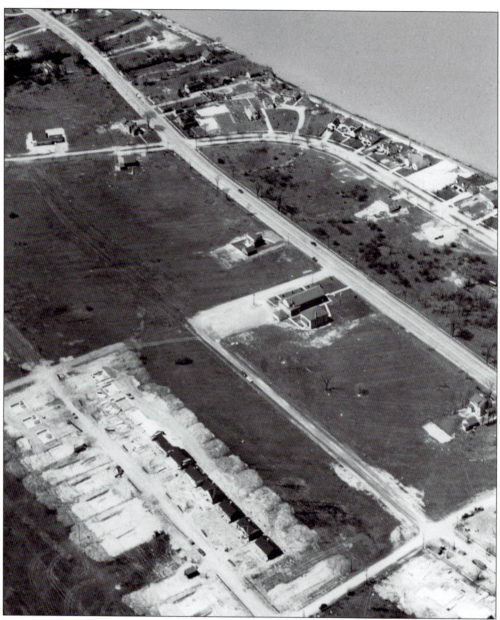

In 1950, the Marbury Photography Studio produced a set of aerial photographs of the entire town of Hamburg that showed the development after World War II. These photographs were taken from a propeller plane, probably with military equipment. This image shows Clifton Parkway, Lake Shore Road, and a housing development being built on Mt. Vernon Boulevard in the lower left corner. Some houses are complete, others do not have roofs yet, some have foundations, and some have only cellar holes. The church of St. Mary of the Lake is visible on Lake Shore Road.

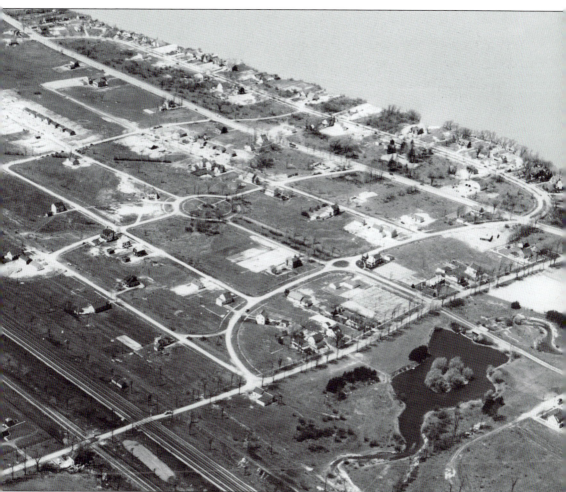

This aerial photograph shows the original design of the Mount Vernon section of Lake Shore. Rogers Road crossed the railroad tracks behind Lakeside Memorial Park leading into Mount Vernon, which was being developed in 1950. This development avoided the normal grid pattern for streets, using curves and circles at intersections. This photograph shows Avery Road curve into Clifton Parkway as well as the circle on Mt. Vernon Boulevard. Clifton Parkway and Morgan Parkway were being developed at this time.

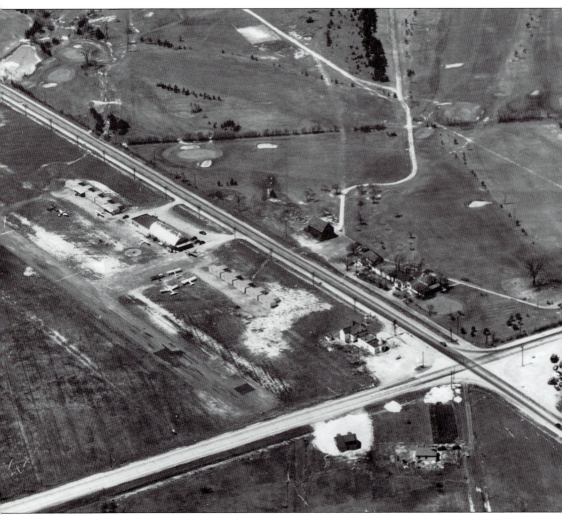

This aerial photograph of the intersection of Camp Road and Southwestern Boulevard shows the South Shore Golf Course and the Hamburg Air Park with several small propeller planes and a hangar in 1950. The golf course was built in 1923 and was designed by Wayne E. Stiles, who used the little creek, woods, and natural hazards to enhance the golf games played here. Both Camp Road and Southwestern Boulevard have been widened to handle the tremendous volume of traffic that passes through today, in striking contrast to the quiet two-lane roads that sufficed about 60 years ago.

Paul Riefler, Inc. was a thriving concrete business at Lake Street and Legion Drive in 1950. Paul C. Riefler was born in Eden in 1906 and started a water- and sewer-line business at age 23 and a construction business from 1928 to 1950. He began selling blue coal and coke in Hamburg in 1935 after learning his trade from his three older brothers. This view shows the ready-mix concrete and concrete block plant with its railroad access at the curve of Camp Road in Hamburg village.

Buffalo businessman Alfred H. Berrick started the Acme Shale Brick Company in Lake View in 1912. His two plants produced up to 20 million bricks per year in 1920 as well as hollow building and drainage tiles. Alfred Berrick kept the factory running during the Great Depression by producing a surplus of bricks that he stored on the property in order to keep his workers employed. The company was later run by Whitney Walrath, Gene Whitney, and Harold Schectman. The factory had a 110-foot-tall smokestack that crashed to the ground during demolition in 1973.

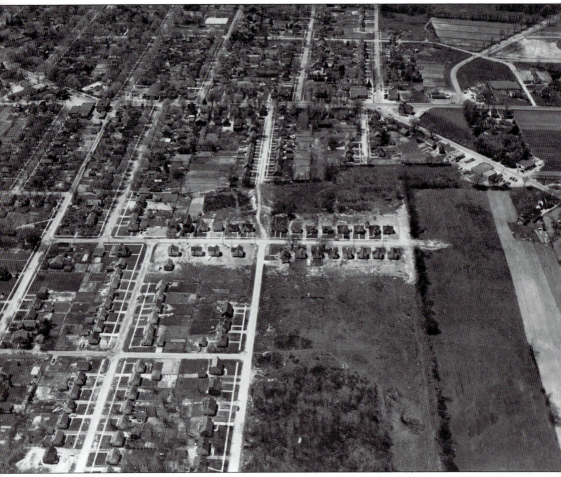

The northern section of Hamburg village had a great deal of development in 1950. The upper right quadrant shows Buffalo Street, Clark Street, and Legion Drive. The Hamburg High School baseball diamond was established by Arthur Howe, who actually started clearing the trees here himself. Hamburg High School was later constructed here. Housing developments were being built on George Street, Sherwood Avenue, and Parkside Avenue in the lower portion of this photograph. These streets were developed by Henry V. Sipprell, and street names came from his family members. Parkside was originally called William Street, but residents did not appreciate the comparison with William Street in Buffalo, and the name was changed.

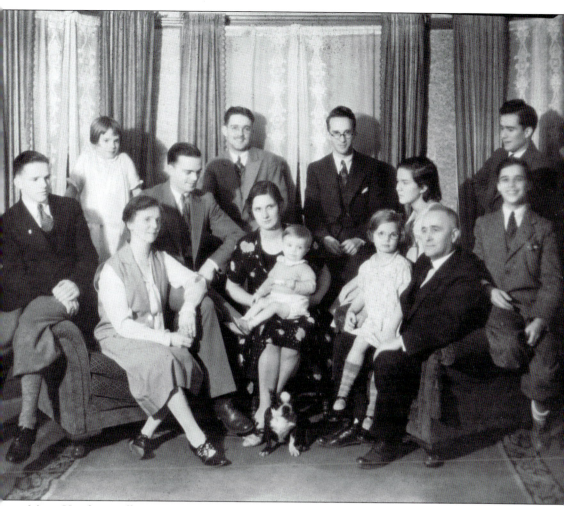

Many Hamburg village streets now bear the names of members of the Sipprell family. Henry Sipprell was a real estate developer who constructed a large number of modest, single-family homes on new village streets. The following are, from left to right: (first row) Mrs. Martha Sipprell, Helen with Bill Jr., Henry with Jean Marie; (second row, seated) George, William, Charlotte and Donald; (third row, standing) Martha, Raymond, Sherwood and Robert. George G. Sipprell was born in 1915, married Eleanor Drehs, and served as Erie County budget director and social services commissioner and as director of the Erie County Agricultural Society. He served as general chairman of Hamburg's sesquicentennial celebration in 1962. Francis Sipprell took this photograph in 1932. His sister Clara Sipprell became a well-known photographer in Vermont. (Courtesy Hamburg Historical Society.)

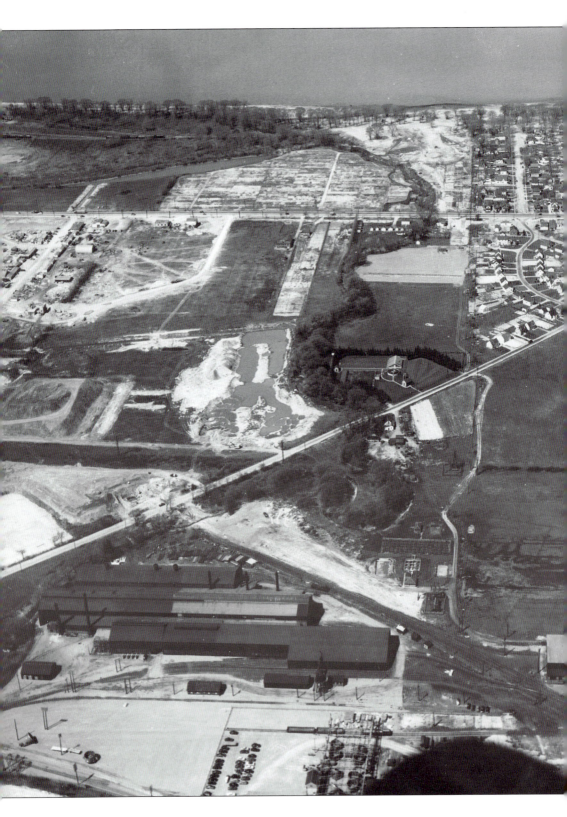

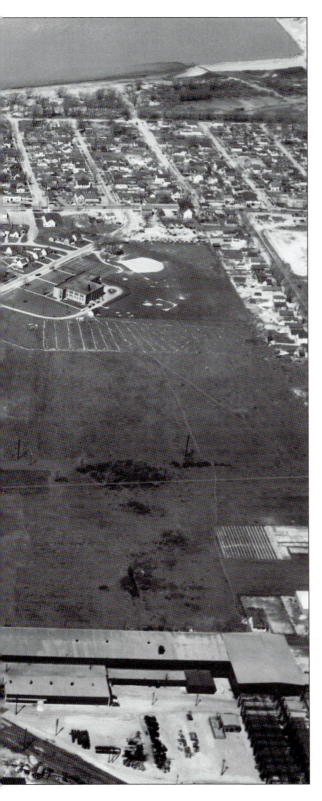

This remarkable photograph shows the industrial district of Blasdell and the community of Woodlawn in 1950. The left portion of this photograph shows Woodlawn Beach and Rush Creek that meanders toward Lake Erie. The Bar Mills buildings are viewed in the lower portion of the photograph. At right, between Lake Erie and Lake Shore Road are Seventh, Sixth, Fifth, Fourth, Lakeview Road, Third, Second, and First Streets in Woodlawn. Two other Woodlawn streets were lost when Bethlehem Steel expanded to the south and homes from those streets were moved to Lake Avenue. The old Mile Strip Road cuts diagonally to the new section of Woodlawn including the Woodlawn High School and the housing lots that were being developed.

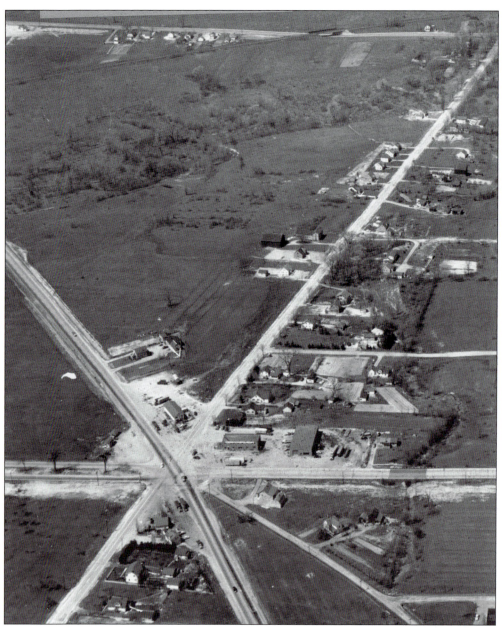

The old Seven Corners did not have much traffic in 1950. Big Tree Road is the oldest road here, established for settlers traveling west. The small community of Big Tree had three tavern-hotels, a store, and there actually was a "big tree" landmark in this community. Southwestern Boulevard, or Route 20, was constructed in the 1920s. McKinley Parkway was one of many roads built in Hamburg by our native son George Burwell Abbott. Today Big Tree and Shelby Roads are not part of the Seven Corners. In 1950, this intersection was governed by a blinking red light. Mrs. Helen Pierce Chapman, a resident of nearby Steelton, had her own method of getting through the intersection. Uncertain of who actually had the right of way, she would stop at the blinking red light for a moment, then blow her horn and go through the intersection.

Seven

Armor, Blasdell, Woodlawn, and Lake Shore

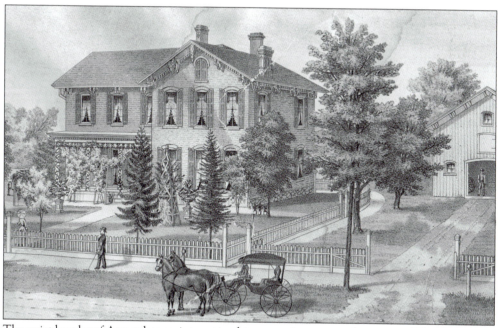

The quiet hamlet of Armor has an interesting history, as it was once the center of Hamburg when the town was established on April 7, 1812. In 1808, the community was known as Wright's Corners, the place where Jacob Wright constructed an early tavern. This beautiful brick building was the home of the Scottish Dr. David Drysdale and his wife, Clarissa, on Clark Street in 1880.

The first hotel in Hamburg was the Hepp Hotel, constructed by Seth Abbott in 1824 in today's Armor. That hotel burned in 1832 but was rebuilt on the same walls. Louis Hepp bought the brick hotel from Reuben Newton in 1861, and Hepp operated the hotel until the early 1900s. This photograph shows John Ostrander in front of the brick walls and chimneys that stood after the blaze. (Courtesy Donald Ahrens.)

Clarence Westley and other workmen are shown with a team of oxen as they clear trees from the woods that were owned by Maria Titus in Armor in 1918. This land off Clark Street has been developed into Maplewood and Woodside Avenues. (Courtesy Donald Ahrens.)

The Ostrander farm and homestead on Clark Street in Armor was home to three generations: Amasa K., John Z., John K. Ostrander, and their families. This photograph from about 1932 shows John K. Ostrander, left, with crossed arms, and his father, John Z. Ostrander, seated at right. This house still stands across from Draudt Nursery. (Courtesy Donald Ahrens.)

This photograph postcard shows the trolley car of the Sunshine Line going down Clark Street toward Armor in 1908. Today's Marie Drive intersects Clark Street at this point. This trolley line was established in 1901 and connected the village of Hamburg with Armor and points north. (Courtesy Donald Ahrens.)

William W. Potter was a well-known photographer in the village of Blasdell; he also composed humorous and satirical verses that mentioned Blasdell residents and events. Potter lived on Pearl Street and is shown here with, from left to right, Mrs. E. A. Hamilton, Helen Hamilton, Willie Hamilton, W. W. Potter, and his wife, Ada Potter. (Courtesy Hamburg Historical Society.)

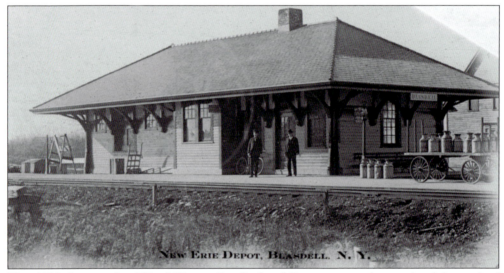

NEW ERIE DEPOT, BLASDELL, N. Y.

This 1906 photograph of Blasdell's new Erie Railroad Depot is a good example of the work of William W. Potter. The angle shows the front and side of the depot, and Potter used sunlight and shadows to indicate the volume of this building. The Erie Depot was a busy place that handled freight and shipments of milk from local dairies such as Trevett Dairy.

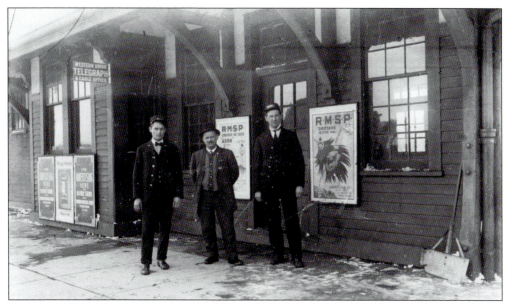

In the early 1900s, the Erie Depot in Blasdell handled trains that connected Buffalo and Jamestown. This station connected Blasdell to the rest of the world with its Western Union telegraph station. Pop Roberts was one of the telegraph agents at the Erie Depot. At circus time, posters appeared on the walls of the depot and on the wall of a barn that faced the station. Blasdell children learned about the arrival of a circus from the posters that appeared suddenly at the Erie Depot. (Courtesy Jim Carlin.)

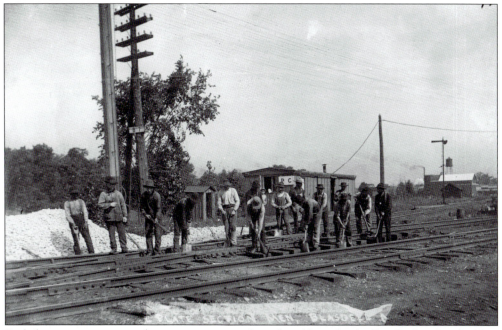

Rail plate section men are shown constructing the railroad lines for the Erie Railroad or the New York, Chicago, and St. Louis Railroad, which ran past the village of Blasdell near the western ends of Orchard and Pearl Avenues. The Buffalo Desk and Table Company factory can be seen in the distance. (Courtesy Hamburg Town Historian, gift of Frank Sumera.)

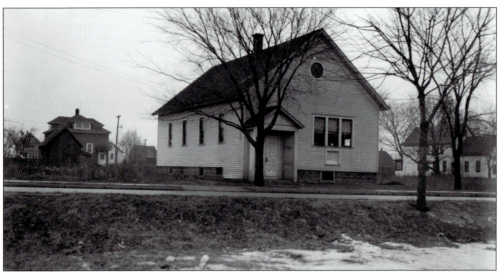

These photographs of Blasdell churches were used by Elma and Franc Titus to illustrate their school newsletter *The Blasdell Bulletinette*. Bethany Chapel was started in 1885 when Messers Townsend, Griedly, and Fairbairn walked from Buffalo to Blasdell to spread the gospel message. The group of "Believers in Christ" built a large meeting hall with a steeple in 1894, and that structure was changed over the years to become this chapel on Arthur Avenue. (Courtesy Hamburg Historical Society, gift of Franc Titus.)

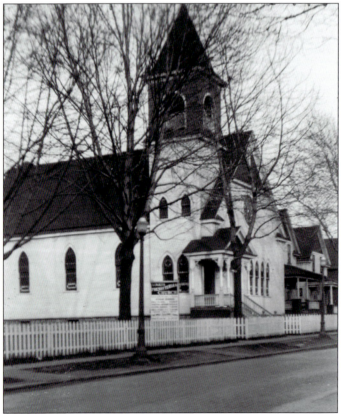

The Buffalo Presbytery sent a preacher to Blasdell on Sundays in 1899 to preach in the old Fraternal Hall until this church on Lake Street was built in 1901 and dedicated May 1902. John H. Kleis selected this site for the church, and he and his sons excavated the cellar and constructed the foundation with stones from their farm. (Courtesy Hamburg Historical Society, gift of Franc Titus.)

Rev. Nelson H. Baker established the parish of Our Mother of Good Counsel in 1905, and this combined church and school building was dedicated on May 13, 1906. Priests from St. Patrick's church in Limestone Hill, today's Lackawanna, ran the parish until Rev. Lawrence Fell became pastor in 1907. The first rectory was constructed in 1908, and the convent was erected in 1918. (Courtesy Hamburg Historical Society, gift of Franc Titus.)

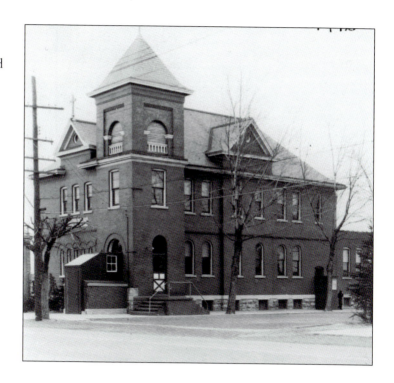

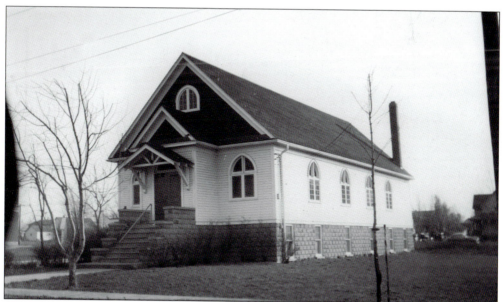

Rev. L. G. Stieg visited Blasdell in 1924 to determine if people were interested in starting a Lutheran church. He established a mission church that first met in the Martin Avenue home of George and Florence Myers. This church on Salisbury and Arthur Avenues was dedicated on July 11, 1926, and Rev. W. Zuehlke served as first pastor. (Courtesy Hamburg Historical Society, gift of Franc Titus.)

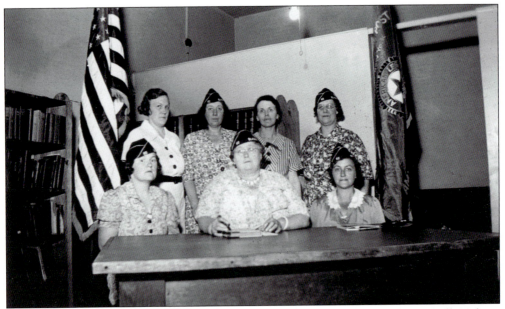

The Ladies Auxiliary of the American Legion, led by Mrs. Robley D. Evans and Mrs. Stella Nelson, started the Blasdell Free Library in 1936. Mrs. Ethel Eighme Thompson is remembered as the early librarian of the Blasdell community and the author of the history book *The Day Before Yesterday in Blasdell*. The Blasdell Free Library was set up in three different rented storefront locations on Lake Street before moving to its own home at 54 Madison Avenue in 1954.

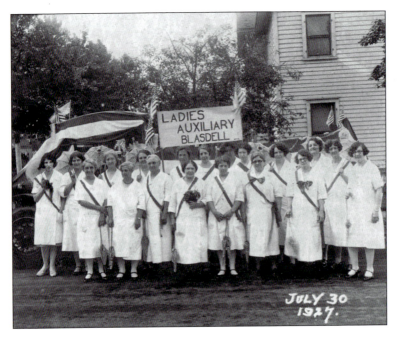

Members of the Ladies Auxiliary of Blasdell pose in front of their parade float truck that was decorated in patriotic bunting on July 30, 1927. The Southwestern Association of Volunteer Firemen of New York held their convention on August 3–5, 1927, and the Ladies Auxiliary was one of the many groups that marched in the convention parade.

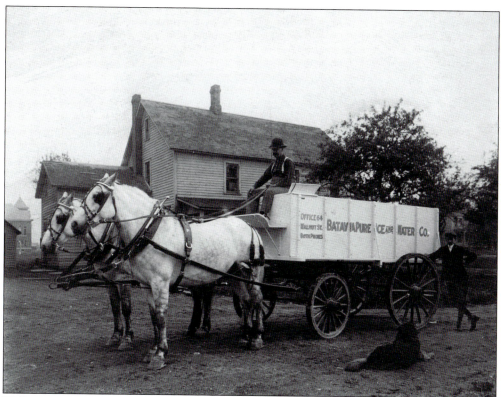

William Page delivered ice throughout the Blasdell community from the icehouse that stood behind the home that he constructed on South Park Avenue at Linwood Avenue. The new church and school building of Our Mother of Good Counsel can be seen at the extreme left of this 1908 photograph that shows William Page in his ice truck with his team of horses. (Courtesy Town of Hamburg Historian, gift of Vernard Cline.)

This Blasdell village home stands on Labelle Avenue at Maple Avenue, an area that has some of the earliest buildings of the old Mile Strip section of Blasdell. Jennie Draper and her daughter Helen and Mr. and Mrs. Ed Wulf and their daughter are standing on the porch. (Courtesy Hamburg Town Historian.)

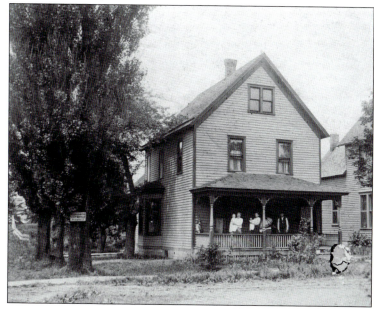

This building stood on the southwest corner of Lake and Labelle Avenues in Blasdell, and two stores were run here about 1910: Mrs. Smith's Cash Grocery and Flour Store on the left and Herbert Swindell's General Store on the right. A few years later, Frank L. Cheeseman joined Mr. Swindell, and they ran their store in Mrs. Smith's storefront, and Froehley's Furniture and Undertaking business went into Swindell's old storefront on the right.

This building, home to Warren F. Salisbury's real estate and insurance business and the Blasdell Post Office, stood next to the general store structure pictured above. Warren F. Salisbury was born in 1866 and served as Blasdell postmaster from 1899 to 1914, and he sold real estate and insurance in his building at 128 Lake Avenue. Warren lived with his wife, Elizabeth, and their children Allen, Wilson, and Ida and his mother, Cynthia.

The two-story brick Bank of Blasdell stood on the corner of Lake and Labelle Avenues and replaced the wood frame general store building that had been destroyed by fire in 1915. The Bank of Blasdell opened in 1920 with capital stock of $30,000, and it was directed by Hamburg banker Henry R. Stratemeier and John F. Jewart. (Courtesy Hamburg Historical Society, gift of Franc Titus.)

During the 1940s, the staff of the Bank of Blasdell used basic equipment, including adding machines, rolls of coins, file cards, and ledgers, as well as a small office for private conversations. The staff included Mary Brogan, Anna Marie "Bunny" Celine, and everyone's favorite bank manager Michael O'Meara. The bank grew and moved to its new, modern quarters at 21 Lake Avenue in March 1951. (Courtesy Jim Carlin.)

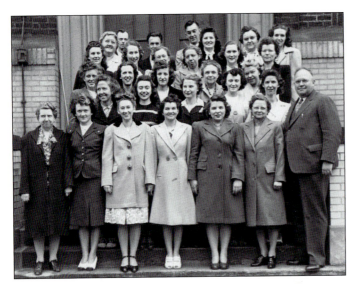

The 1945–1946 faculty of Blasdell High School were warm and special people, and their smiles reflect their devotion to their school and its students as well as the optimism that swept the nation after the end of World War II. Many of the staff had long and devoted careers at this school, notably Ruth Archer, Ruth Pray, Elma and Franc Titus, Wilbur Morganfeld, and Charles E. Buesch. (Courtesy Hamburg Historical Society, gift of Franc Titus.)

Elma Titus taught in the Blasdell schools from 1925 to 1971, and her sister Franc E. Titus taught from 1931 to 1971. Elma's contract from 1935 shows she was paid $38 a week for 40 weeks. This contract was void if any of the women teachers got married. This photograph shows the girls from Elma's second class, the seventh-grade girls from 1926, the year a major addition was built onto the Blasdell School. (Courtesy Hamburg Historical Society, gift of Franc Titus.)

Blasdell High School's graduating class of 1913 included these four young people: Gladys Wyman Taylor, Ethel Eighme Thompson, Arlene Kohner Lucas, and Milford Burgwardt. At that time, the Blasdell School had students of all ages, from first grade through high school. (Courtesy Jim Carlin.)

Blasdell High School's championship basketball team of 1947–1948 included, from left to right, (first row) Carl Bodenstedt, Edward Kozak, Hugh Salisbury, Leo Prusak, and Charles Preston; (second row) Coach Mead, Thomas Hooper, Jack Keefe, Coleman Suto, George Mills, Donald Grinder, Robert Dillingham, and Principal Charles Buesch; (third row) Robert McKnight, Dominic Schiavone, Clarence Woods, and Leroy Harmon. (Courtesy Hamburg Historical Society.)

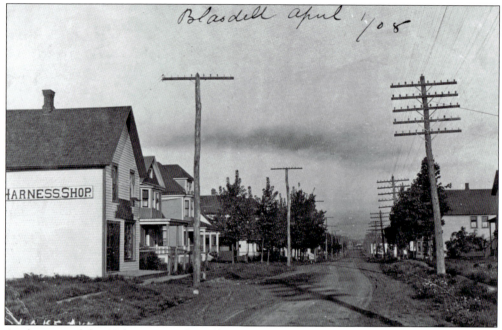

Blasdell april 1/08

At the turn of the 20th century, the village of Blasdell was developing at both ends of Lake Avenue. The railroad station and Blasdell Hotel were at the west end near the railroad tracks, and this view of Charles Poey's harness shop was taken from the east end, near today's South Park Avenue. Charles Poey and his wife, Eugenie, came from France in 1882 and this view of their shop on Lake Avenue dates from 1908.

Carl A. Trevett came to Blasdell in March 1911 and took over Charles Poey's store at 16 Lake Avenue, starting this Red and White grocery store in 1936. When Pops Trevett retired in 1958, Bing Putnam and Bob Corcoran bought the business and eventually opened the Super Duper farther down Lake Avenue in 1960.

This beautiful Lake Avenue home was one of five that were built for members of the Cynthia and Charles Salisbury family. Charles Salisbury came to the area in 1850 and married Cynthia Osborn, and they settled on the Mile Strip. This house was constructed for their son Warren F. "Warney" Salisbury and his wife, Elizabeth Odell. Warney served as the postmaster for Blasdell and became an insurance agent. (Courtesy Jim Carlin.)

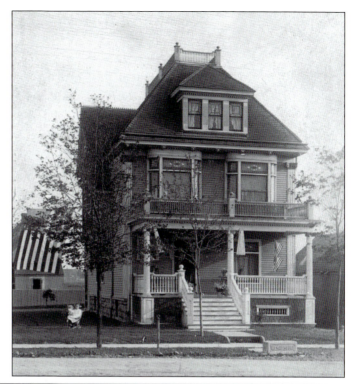

In 1921, someone noticed how long it took the railroad train to come down the hill in Blasdell, and someone challenged two barbers to see if they could give 16 men haircuts before the train reached Lake Avenue. This photograph shows the "Carlin's Baldheaded Sprudles," the men who had their heads shaved at the barbershop of J. L. "Roy" Carlin. (Courtesy Jim Carlin.)

THE THIRD GREEN

PINEHURST COUNTRY CLUB ·

LAKE SHORE BOULEVARD
LAKE VIEW, N. Y.

Many communities have been built along Hamburg's Lake Shore over the years, including the Pinehurst Country Club that was developed by the Harrison Real Estate Corporation in 1928. This was constructed in today's Clifton Heights area with the Pinehurst Inn, a golf course, a beach, playground, and a relaxing lifestyle. The Pinehurst Country Club promised a nine-hole golf course and a clubhouse overlooking Lake Erie. One-third of their 200 acres was to be devoted to recreational facilities with tennis courts and 350 feet of beach, as well as croquet courts, for less strenuous activity. Parents could play golf or participate in other recreational activities at the Pinehurst Country Club, and the grounds were advertised as a paradise for children with "woods to roam, trees to climb, fields to explore and romp in."

"HAPPY DAYS"
IN THE
CHILDREN'S PLAYGROUND
PINEHURST COUNTRY CLUB
LAKE SHORE BOULEVARD
LAKE VIEW, N. Y.

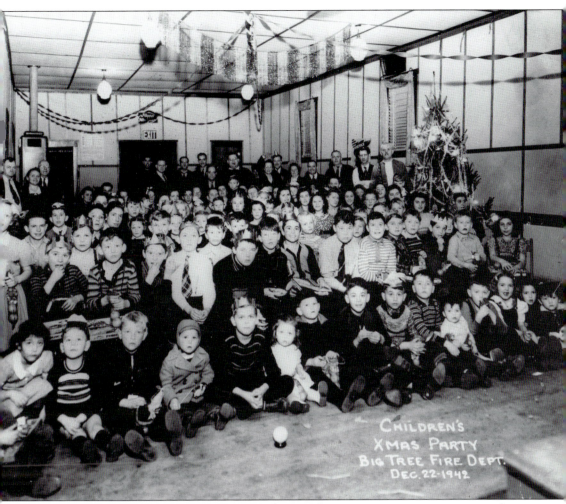

CHILDREN'S XMAS PARTY BIG TREE FIRE DEPT. DEC. 22-1942

The Big Tree Fire Department was a great social center for its community, sponsoring parades, field days, and this Christmas party for boys and girls that was held December 22, 1942. This fire department was established in 1936. That year, groups of men gathered at three different places to discuss the need for a Big Tree fire department. They gathered at Albrecht Brothers' Gas Station, at Schoen's Grille (later known as the "Hitching Post"), and at Joseph Kryzak's garage. William Koenig and Ira Milks passed letters through the community asking men to join the Big Tree Fire Department. An excellent history of the community and the fire department was written in 1956 by Clifford O'Melia, titled *The History of Big Tree*. Segments of this book appeared weekly in *Blasdell Herald* beginning March 8, 1956. (Courtesy Hamburg Historical Society.)

Y.W.C.A. SUMMER HOME, ATHOL SPRINGS N.Y. 86.

Athol Springs was considered a salubrious place in the 1890s for several reasons. This building was constructed as a cholera hospital, and it later became the YWCA Summer House that was used as a fresh air camp for city children. Actual springs in the area were thought to have medicinal properties, and Dr. R.V. Pierce had a home in Athol Springs in addition to his noted hospital in Buffalo.

Boulder Windmill Athol Spgs

This circular stone windmill was built in Athol Springs before 1912 and probably stood where the scoreboard on St Francis athletic field is today. Athol Springs was known for its spring water and for the 1894 Cholera Hospital that later became the YWCA summer camp for city children. A windmill was used farther south on the lakeshore at the Wanakah Water Works to bring water up from the lake to a dozen customers in the 1890 era.

Atwell and Sophia Ahrens Saunders moved from Blasdell to Athol Springs to operate this general store on Camp Road. Their eldest daughter, Helen, recalled sitting on the front steps as Camp Road was paved in brick. The store later had a gas pump in front and a scale on the north side to weigh deliveries of coal. Atwell's brother Lyman ran several businesses in Blasdell, and the name of Saunders became synonymous with Athol Springs.

Hamburg architect Frank A. Spangenberg designed the Athol Springs School that was built at a cost of $30,000, including furnishings, and dedicated on November 4, 1920. This school was constructed on high ground and provided an auditorium for the community to use. Ford R. Park, principal of Hamburg Schools, described the building as "the most modern, beautiful, and useful school building . . . ever seen in a rural district."

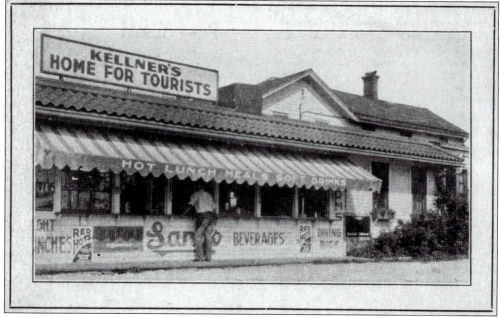

Kellner's Tea Room stood on Lake Shore Road at Oakwood, and here Susie Kellner offered cabins for travelers, as well as groceries, snacks, and lunches that were served through the open counter under the awning. Kellner's was known for hiring young men from Father Baker's Home for Boys in Lackawanna.

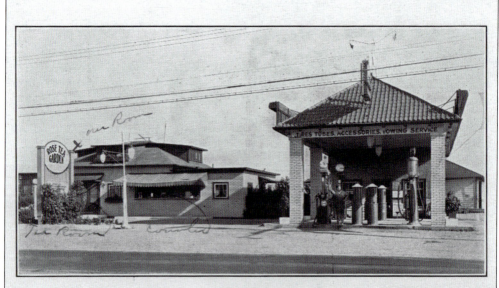

For a quiet rest and food that's best, the Rose Tea Garden Kendall Camp beats all the rest.

The Rose Tea Garden and Kendall Camp was in Lake View on Lake Shore Road. It was operated for years by a man named Alessi, known as "Alice," before he moved to Southwestern Boulevard near Eighteen Mile Creek.

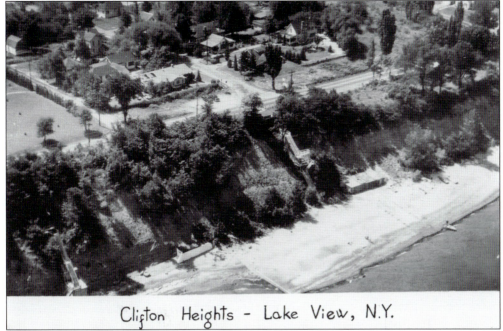

The lakeshore of Hamburg has numerous communities, each with its own name. This aerial photographic postcard shows the cliffs, beach, and residential street of Clifton Heights, off the old Lake Shore Road. Other lakeshore communities include Athol Springs, Idlewood, Lake View, Locksley Park, Mount Vernon, Pinehurst, Wanakah, and Walden Cliffs.

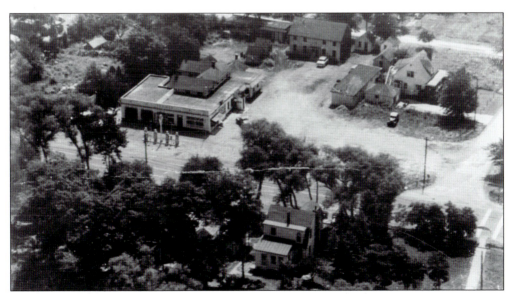

Route 5, or Lake Shore Road, offered a scenic drive for people from Buffalo to come to Hamburg's shore of Lake Erie, and many small businesses were developed along that highway including the Johnny Lee Texaco Station and the Wanna-Bank Motel in Wanakah.

The Wanakah Water Works has expanded in several stages since it was founded in the 1890s. In November 1932, John T. Roberts served as company president, and he administered an expansion project that employed 100 men for 75 days as they laid 800 tons of cast iron piping and installed 50 fire hydrants and a 250,000 gallon steel tank to establish a new Lake Shore fire district.

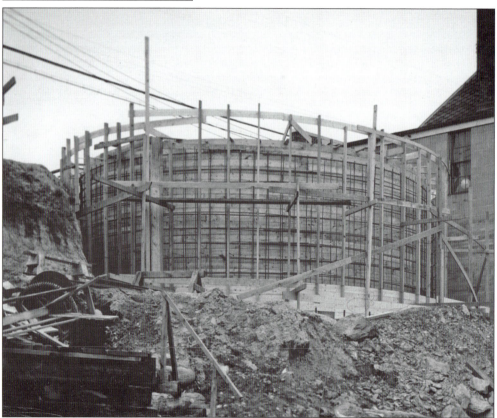

This photograph of the Wanakah Water Works Company shows the construction of the flocculator system developed by Alfred "Ted" Roberts, son of John T. Roberts, to purify water by moving it in a deep circular tub and allowing impure particles to drop to the bottom. (Courtesy Hamburg Town Historian.)

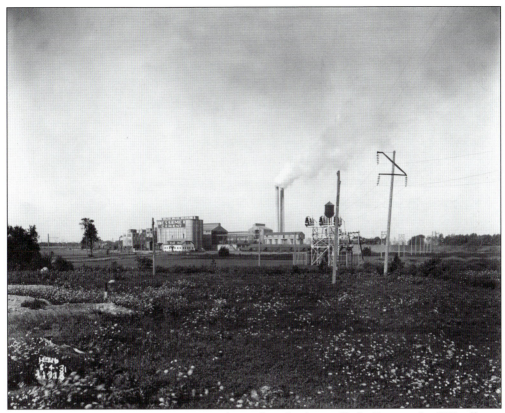

The Penn-Dixie Cement Corporation was located on the shore of Lake Erie, south of Woodlawn, west of Blasdell, and north of Hoover Beach. The plant was built in 1926 by the Federal Portland Cement Company. It was expanded in 1956 when it was purchased by Penn-Dixie. The plant produced cement, mortar, and masonry cement. In 1962, Penn-Dixie had 210 employees and was Hamburg's third largest industry. This photograph was taken in 1931. (Courtesy Town of Hamburg Historian.)

Twenty-four attractive cottages were built in the community of Idlewood about 1895 to house employees of the Idlewood Bicycle Factory. As many as 600 people worked in this industry to manufacture bicycles to satisfy the craze that was sweeping the nation. (Courtesy Hamburg Historical Society.)

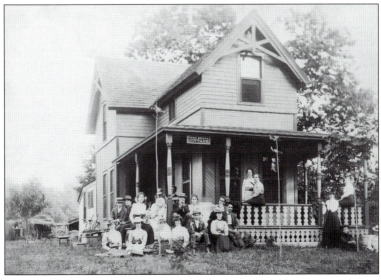

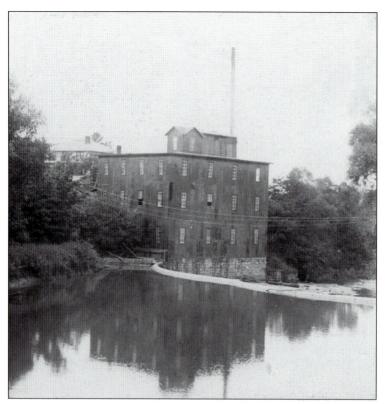

Water behind the curved dam of Eighteen Mile Creek reflects the image of the mill that Oliver Cromwell Pierce established in Water Valley. Oliver Cromwell Pierce built a mill on Eighteen Mile Creek in Water Valley that produced 200 barrels of flour per day. This photograph shows the place where Hamburg's first electric generator was set up by Herbert D. Pierce in 1889. It produced enough electricity for 27 lights that were installed in Hamburg village in 1893.

Irishman William McGee settled in Hamburg about 1860 and operated the gristmill on Eighteen Mile Creek that was built in 1806 by the town's earliest settler John Cummings. The McGee family had at least 11 children, and William's son Joseph took over the operation of the mill by 1870, while William and his other children worked on their farm west of Water Valley.

F. W. Cook established a lumber and hardware business in Lake View in the late 1880s that was later owned by Ralph Fierle and then sold to Will Meyn. This photograph shows the family of F. W. Cook. From left to right are Chas Cook; his daughter Mary; his wife, Ella; Mr. Pardee, Ella's father; Marion Cook Christopher; Betty Cook; Ma Cook; Lea, wife of Lester Cook; Richard Christopher; Pa Cook; Donald Christopher; Leonard Christopher; Billy Cook; Lester Cook; and Jane Cook. (Courtesy Hamburg Historical Society, L.A. Hazard Collection.)

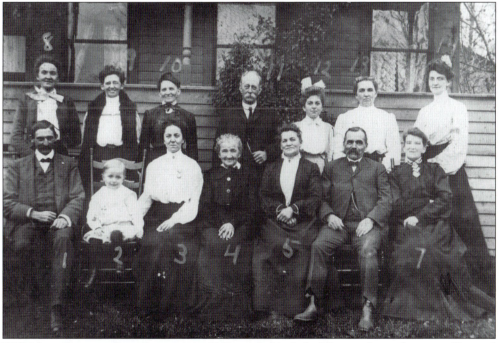

Will Meyn Sr. came from Germany in 1843, settled in Lake View, and ran the post office and general store. He married Adah Buxton, daughter of Spencer Buxton and Serephine Wood. From left to right are (first row) Will Meyn; Curtis Meyn; Adah Buxton Meyn; Carolyn Meyn, Will's mother; Carrie Meyn Shear; John Shear; and Bertha Meyn Thompson; (second row) Amelia Meyn, Ella Meyn, Emma Meyn Pahl, Francis Pierce, Gladys Pierce, Louise Meyn Pierce, and Helen Meyn. (Courtesy Hamburg Historical Society, L.A. Hazard Collection.)

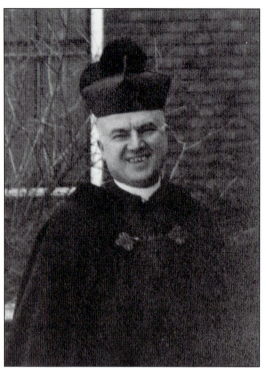

Rev. Leo V. Toomey was born in Canada in 1890 and came to the United States as a young boy. He served in Farnham before coming to Hamburg where he was pastor of Our Lady of Perpetual Help, Our Lady of Grace, and Our Mother of Good Counsel Churches before working at the larger St. Theresa Church on Seneca Street. This colorful person, known affectionately as the "Bishop of South Buffalo," passed away in March 1969. (Courtesy Jim Carlin.)

This photograph of the Knights of Columbus of Our Lady of Perpetual Help parish in Lake View was taken May 15, 1932, and shows how rapidly this parish developed since it was established 10 years earlier. This attractive church was designed by architects Carl Schmill and Son, and the church was dedicated on October 15, 1922. (Courtesy Hamburg Historical Society.)

The Hamburg Turnpike, or the Lake Shore Road, was the main road through Woodlawn leading to Buffalo, and this photograph from 1908 shows the stores, hotel, trolley line, and one automobile on this quiet dirt road. This view looks north toward Buffalo. (Courtesy Hamburg Town Historian, gift of Frank Sumera.)

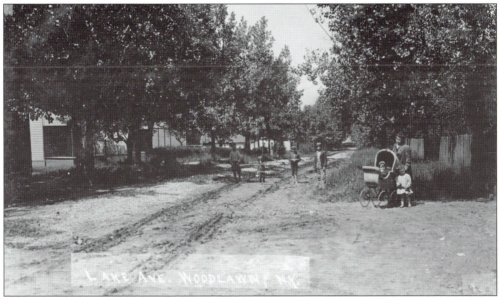

Lake Avenue connected Blasdell and Woodlawn, and this photograph shows how undeveloped that road was in the early 1900s. Woodlawn was originally a few large farms, and things started to change when the Woodlawn Beach and Cottage Company started to develop the community after 1891. Woodlawn was primarily a summer community and frequently people stayed there in tents before cottages, the Woodlawn Beach Amusement Park, and the long dock were built. (Courtesy Jim Carlin Collection.)

www.arcadiapublishing.com

Discover books about the town where you grew up, the cities where your friends and families live, the town where your parents met, or even that retirement spot you've been dreaming about. Our Web site provides history lovers with exclusive deals, advanced notification about new titles, e-mail alerts of author events, and much more.

Arcadia Publishing, the leading local history publisher in the United States, is committed to making history accessible and meaningful through publishing books that celebrate and preserve the heritage of America's people and places. Consistent with our mission to preserve history on a local level, this book was printed in South Carolina on American-made paper and manufactured entirely in the United States.

This book carries the accredited Forest Stewardship Council (FSC) label and is printed on 100 percent FSC-certified paper. Products carrying the FSC label are independently certified to assure consumers that they come from forests that are managed to meet the social, economic, and ecological needs of present and future generations.

FSC
Mixed Sources
Product group from well-managed
forests and other controlled sources

Cert no. SW-COC-001530
www.fsc.org
© 1996 Forest Stewardship Council

Find Your Place in History.